JN116715

# 「紙の温度」が出会った 世界の紙と日本の和紙

著＝紙の温度株式会社

前ページに綴じ込んでいる紙は、
P.75で紹介しているドイツのホイルペーパーです。
本書ではその中から7種類を選び、どれか1枚を綴じ込んでいます。

2

3

4

# はじめに

話・花岡成治、城ゆう子（紙の温度）　文・鈴木里子

ようこそ「紙の温度」へ！「紙」も「温度」もふだんよく使う言葉なのに、ふたつが合わさるとちょっと不思議な響きになるからおもしろい。「紙の温度」は日本各地の和紙と世界の紙を扱う紙の専門店。名古屋の有名な神社、熱田神宮のすぐそばにあるお店だ。ピンク色のユニークな外観にひかれて入ってみると、その品揃えに驚きを超えて圧倒されるに違いない。数えきれぬほどの棚のすべてに、びっしりと紙が入っている。

私たちの生活に、紙は欠かせない。まわりをくるりと見回してみれば、なんらかの紙があるだろう。本、雑誌、メモ用紙、郵便物、ティッシュペーパー……。どれだけネットが普及しても、紙は私たちの生活に溶け込んでいる。でも「紙の温度」にある紙は、そういう紙とは違って初めて目にするものばかり。とってもきれいな本物の花が漉き込まれていたり、どうやったらこんなに薄い紙がつくれるのか想像できないほど薄かったり、紙とは思えないほど凹凸していたり。そんなワクワクする紙やそれを使った紙製品などが、なんと2万アイテムも置いてある。1日かかってもすべてを見るのは無理だろう。毎年入れ替わりもあるから、何回来ても完全制覇することは難し

い。だから何度でも来たくなる。

そしてここにある紙を見ていると、紙は誰かしら人の手がつくり出したものだといい、当たり前のことに気づかされる。いま身の回りにある紙の大半は機械でつくられたものだけれども、本来は1枚1枚手で漉かれてきた。木や草を原料とし、水にさらして、煮て、繊維をほぐして、漉いて、干して、やっと1枚の紙になる。ものすごく手間のかかる工程を経てできあがる。紙は自然とともに歩み、人の手が育んできた。

そうやって生まれた紙に触れてみると、ふんわりとあたたかい。そう、「紙の温度」という名前には、「紙のぬくもりを伝えたい」という気持ちが込められている。この本を手に取ってくれたあなたは、手漉きの紙に触れたことはおありだろうか。「紙の温度」で初めて触れた人も多いというから、昨今では触れる機会がぐっと減っているのかも知れない。ぜひ、見るだけでなく触れてみて欲しい。人の手がつくるものはこんなにも温度を持っているのだということが実感できる。

開店したのは1993年だから、もうすぐ30年。代表取締役社長の花岡成治さんがスタッフとともに日本の産地を巡り、生産者や加工する人を訪ね、関係を築いたみなさんから仕入れている。海外からも多く輸入していて、生産の現場に赴くこともたびたびだ。どんな人たちが、どんな環境でつくっているのかがわかっているから、売る方にも気持ちがこもる。オープン当初の品揃えは1200ほど。それでも充分に豊富だけれど、特徴や魅力が書かれたPOPを読むと、その思いが強く伝わってくる。

「こういう紙が欲しい」「海外で見たあの紙は置いてないかな?」というお客さまの声

店内に置かれた
日本の和紙と世界の紙には、
「紙の温度」スタッフによる
商品説明がつく。

に「ない」とは言わないと心に決めて探し続けた結果、2万アイテムにもなってしまった。合い言葉は「きっとある」。だからここにしかない紙がいっぱいあって、仕入れ先の人がびっくりすることもあるくらい。それでもまだ、出会ってない紙は山ほどあるから大変ですと花岡さんは笑う。

本書では、「紙の温度」が創業してから30年の間に出会い、そしてお店に並べてきた万を超える紙から厳選した世界の紙と手漉き和紙を、「紙の温度」を創立し現在も社長を務める花岡さんと、創業時から「紙の温度」を、そして花岡さんを支えるスタッフである店長の城ゆう子さんに紹介していただく。世界中でこんなにも面白く素敵な紙がつくられていること、1枚の紙にお国柄や人柄があらわれていること、文化が内包されていることが伝わったら嬉しい。手漉き和紙の繊細さ、厳しい自然のなかで漉かれた紙の美しさ、和紙が生まれてからの1400年という時間を感じてもらえたらなお嬉しい。紹介する紙のなかには、もうつくることが難しいものもある。お店を続けるなかで、なくなってしまった紙は内外問わずたくさんあるという。後継者がいなかったり、材料の入手が難しくなったり、理由はさまざま。「うちはなるべく、貴重な紙ほど途絶えさせたくないという思いで頑張っています。ここで扱わなかったらなくなってしまう紙もありますから」と花岡さんは言う。いま見ることのできる最上の紙が集まるお店が教えてくれる、世界と日本の紙の魅力と特徴をぜひご覧ください。

世界の紙

# ロクタ紙

みなさんはロクタという植物をご存じですか？　ネパールの標高1800メートル以上の山間地に自生する、雁皮や三椏と同じジンチョウゲ科の植物で、和紙の原料となる楮、雁皮、三椏に比類する製紙原料です。このロクタを原料として漉いた紙がロクタ紙です。ロクタに三椏など他の原料をブレンドしたものもロクタ紙と呼んでいます。

同じくヒマラヤ高原を抱く近隣のブータンは、より高地であるがゆえに急流でダムがたくさんあり、水資源に恵まれているのに対して、ネパールは少なく、さらに電気の供給が進んでいません。そのため産業に乏しく、製紙はフェルトと並んで重要な産業のひとつと言われています。

工業化しすぎていないということは、ハンドメイドがまだまだ残っているということ。溜め漉きが主流ですが、現地に見学に行った際、アジアでも廃れたと言われていた撓紙法が残っているのを見たときは驚きました。　撓紙法は紙漉き手法

のひとつで、絞った原料をすくって簀の上に置き、重みで沈んだそれを手で広げるという、原始的な方法です（17ページ写真）。もう現存していない、幻の製法だと思っていた撓紙法に、偶然遭遇できたのです。見つけたのは、その時同行してもらっていた、私の紙の先生である宍倉佐敏さん（76ページ参照）でした。「これはものすごく貴重で、発見に値する！」と興奮なさっていたのを覚えています。

ロクタ紙を手に取ると、その素朴さ、温かみにほっとします。バディと呼ばれる草などをブレンドしたものが多く流通するなか、ロクタだけでつくられた「純ロクタ紙」は、近年ヨーロッパやアメリカからも関心が持たれている貴重なものです。ブレンドしたものはガサガサしていますが、純ロクタは素朴な中にもどこか雁皮紙を感じさせるツヤがあります。

ただ、現地の人はロクタと三椏に大きな違いはないと考えている節も見られますから、彼らが純ロクタの価値をどこまで

純ロクタ紙の薄いもの（左）と厚いもの（右）。

染めたタイプのロクタ紙。左から4枚が草木染め、右は揉み紙タイプ。

わかっているかはわかりません。ですがこんなにいい紙を漉いていることをわかってもらいたくて、工房を訪れた時に思わず日本語で「こんなに素晴らしい紙なのだから、もっと誇りを持ってつくるべきです！」と熱く語ってしまったこともあるくらいです。すると知らぬ間に人々が集まり、耳を傾けてくれました。日本語でも、「紙」が熱意ある共通言語となって通じたのではないかと思います。

また、ロクタ紙はとても強いのも特徴です。この点はまだあまり知られていないので、もっと認知されていい点だと思います。ミシンで縫うこともできます。近年はその丈夫さを活かしたバッグやペンケース、小物入れなども人気です。「紙の温度」でも、巻いた紙を持ち運びできるオリジナルの肩掛けエコバッグをつくっています。

素朴で強くて、しかも安価。約50×75センチの純ロクタ紙が200円前後ですからお値打ちです。内装材としても人気があり、和紙にはないラフな質感がかえっていいという建築家やインテリアデザイナーの方も多いです。

ロクタ紙は加工するとものすごく水に強いので、染めに向きます。とりわけロクタだけでつくられた純ロクタ紙の強度は特筆もので、染めてから手でギュッと絞っても破けないほど（17ページ写真）。現地で染めておいてからトタン板の上に伸ば

して乾かすのを見ましたが、そんなやり方でも大丈夫なので（17ページ写真）。

ネパールへはこれまでに、10回ほど行っています。家族みんなで原料のロクタや三椏の皮を剥いでいるところを見せてもらったり（16ページ写真）、崖の下にある三椏の畑を見にいったり、漉きや染めの工程ももちろん見学しました。印象に残っているのが、山奥にある工房に行ったときのことです。ここは一番古くから付き合いのある工房ですが、道路という道路っぱみたいなところに、染めた紙がぽんぽんと放ってあるんです（16ページ写真）。散らばっているという方が正確かもしれません。これから干すから置いているんだと言われて、なんとも大らかなつくり方にお国柄を感じました。12ページの撓紙法も、この工房で見たものです。

ネパールの紙は生成りや染め紙以外に、プリントもあります。以前は手彫りの木版でパターン柄を押す「ブロックプリント」が主流でした。彫り師に会いに行ったりもしましたが、最近はスクリーン印刷がブロックプリントに取って代わるようになりました。少し残念な気もします。モダンな柄が増えてきていて、これはヨーロッパのデザイナーが現地に滞在して指導に当たっているからです。ネパールは、ゆっくりと変化のときを迎えています。

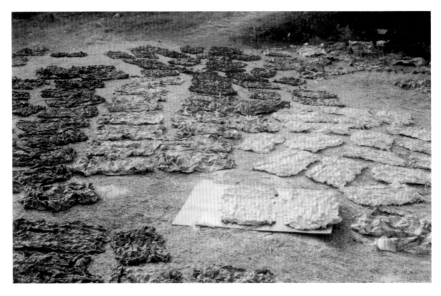

染めたロクタ紙がしわくちゃのまま地面に置かれて乾かされている。

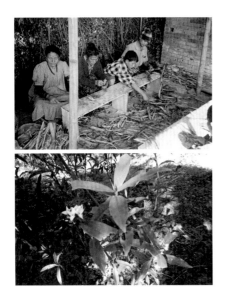

上）家族総出で原料の皮を剥いている。
下）原料となるロクタ。

このような険しい山をランドクルーザーで走り、三椏を
栽培する畑へ向かう。

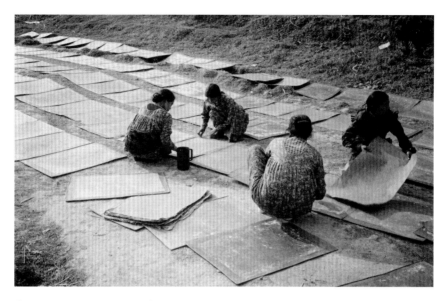

染めたロクタ紙をトタン板の上に広げて乾かす。

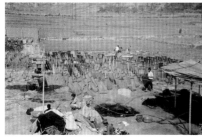

ロクタ紙を広げて乾かす場所はこんな自然の中。

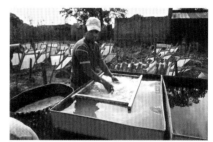

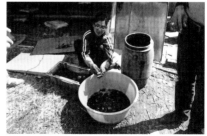

上）原紙的な漉き方撩紙法で今も紙がつくられていた。
下）手漉きしたロクタ紙を染料に入れて手で
ぐしゃぐしゃっと揉んで染めている。こんなに揉んでも
大丈夫なのは強靭なロクタ紙だからこそ。

左から雲母入りロクタ紙 (3色)、バナナペーパー、
型押しデザインのロクタ紙、花柄透かしロクタ紙。

左から矢車草を漉き込んだ花入りロクタ紙、プリントしてロー引きしたロクタ紙、
バティック（ろうけつ染め）したロクタ紙（3色）、ロー引きして揉みを入れたロクタ紙。

# サーペーパー

私たちが初めて扱ったアジアの紙は、タイのものでした。

1995年のことです。和紙より求めやすくて、お客さまに喜んでもらえる紙を探してたどり着いた最初の土地です。日本でいう「和紙」と同じように、タイの紙はすべて「サーペーパー」と呼ばれますが、「サー（saa）」はタイ語でカジノキを指します。カジノキはクワ科コウゾ属の木で、タイ楮とも呼ばれます。日本にも分布していて、楮との交配が進んでそれを楮と間違える人も多く、注意しないといけません。カジノキは大木になります。そして日本の楮よりも油分がいくぶん多く、そのため丈夫な紙ができます。

12ページのロクタ紙に比べると和紙に近い風合いなのは、楮の仲間だからでしょう。溜め漉きなので地合いのムラが生じ、それを好む方もいます。取り扱い始めた当初、書家の方々が気に入っていたのを思い出します。生成りのほかに、椰子の実の繊維で装飾したものや、マンゴーの皮を混ぜて漉いたものなどもあります。また、樹皮のすぐ下の部分をそのまま紙のように使うというワイルドな「樹皮紙」もあって、これはファッションの分野などでも使える可能性を秘めています。タイでは花を漉き入れる時にわりと大味になってしまうのですが、私たちがお付き合いしていたところは小花を散らしたりと、センスが良かったんです。とても細かな模様の落水（乾く前に水をかけて模様をつくる技法）紙や、エンボス加工で花や葉の模様をつけたもの、バティック、ラフィアの繊維を格子状に漉き込んだものなど、タイでは本当にいろいろな紙を見つけて、みなさんに紹介してきました。

2011年、タイは首都バンコクも含めて見舞われた大洪水によって、甚大な被害が出ました。さまざまな製造業が大打撃を受け、製紙業にも及びました。この時、ハンドメイドの職人の多くが廃業してしまい、本当に残念でなりません。

写真左からベーシックなサーペーパー、未晒し樹皮紙と晒した樹皮紙。

1）サーペーパーをつくる工場。2）サーペーパーの原料となるカジノキ。3）工場前には紙を
天日で乾かすための漉き枠がたくさん積まれている。4）工場を訪ねた花岡さん（写真左から2人目）。

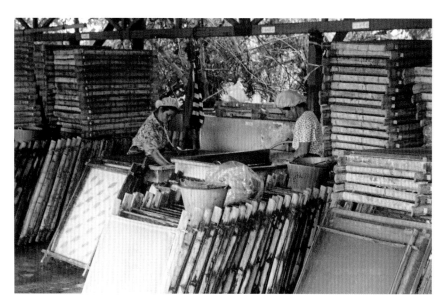

半屋外の漉き場でサーペーパーを漉く女性たち。

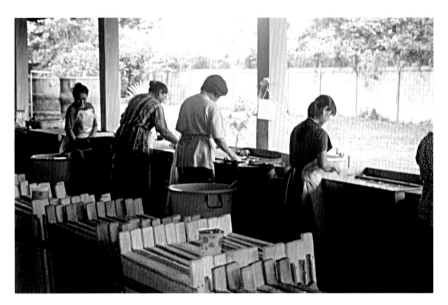

花入りのサーペーパーを漉いている。

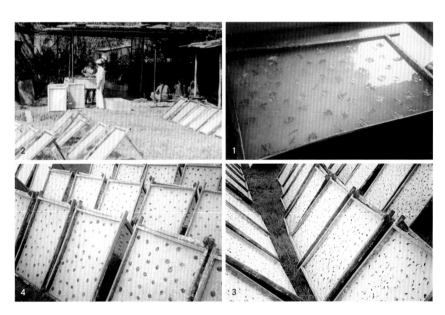

1) 紙料を入れた漉き枠の上に花や葉をきれいにならべていく。2) 漉いた紙は天日に干して乾かす。
3、4) さまざまな花や葉が入ったサーペーパーがつくられていた。

さまざまなサーペーパー。写真左からバティック、ブーゲンビリア入り、リングペーパー、葉入り。

こちらもサーペーパー。写真左からバナナファイバーで漉いたもの、ラフィア漉き込み、
ココナッツファイバー入り、立体エンボス、マンゴーファイバー入り、
落水の技法でつくられたレースサーペーパー。

水たまりで漉くという驚きの手法
村民総出でつくってくれる素朴の極み

# トラディショナル サショー

ブータンはネパールとお近くの国です。二カ国同時に最初に行ったのが1999年のことで、現地の人に案内してもらいました。国際空港から首都ティンプーまで車で向かったのですが、未舗装の道路でガタガタと揺られるだけでもキツいのに、いろんな動物が我が物顔で、私たちの行く手を遮ります。やっとホテルに到着したのは5時間後でした。

私にブータンの紙を現地に見にいくよう、強くすすめてくれたのは、「和紙文化研究会（非営利の自主的な勉強会。私も会員です）」に在籍していたフランソワーズ・ペローさんというフランス人です。ブータンの紙の原料で代表的なのはダフネです。ジンチョウゲ科でネパールのロクタとよく似ていて、ルーツは同じなのではないかと推察します。当時、ブータンには紙漉きはたった2軒と少なく、どちらも島根県浜田の石州和紙から技術指導を受けていました（1986年から続行）。当然、和紙に似ます。ですが、ペローさんが見せ

てくれた紙はもっと素朴でした。私がほしいのは昔ながらのものなんですと、1軒の方の紙漉きを切り盛りしていた女性に伝えました。すると、ティンプーから車で3日かかる村の村長さんに頼むと、村総出で漉いてくれると教えてくれたのです。漉いてもらったらトラック一杯分買い取るようにと助言され、本当にそうしました。これが驚くような漉き方で、河原に穴を掘ってすくった水を入れて、そこで漉くんです。

日本式に言えば溜め漉きで、この方式で漉いた紙がサショー、コップで原料を注ぐ撹紙法で漉いたものをレショーと呼び分けています。乾かすための板もなくて、岩や草の上に置いて天日乾燥させます。だから日本に届いた紙を検品すると、土が付いているものもあります。シワの入った素朴な紙ですが、サショーは「紙の温度」でもとても人気で、私はアジアでこの紙が一番好きです。

昔から受け継がれた方法でつくられたサショー。
「紙の温度」ではトラディショナル サショーと呼んでいる。

# 傘の紙

　ミャンマーへ視察に行ったのは1999年です。JETRO（日本貿易振興機構）で、東南アジアの市場調査などに携わっていた荒木義宏さんからお誘いを受けてのことでした。漆器、木竹製品、伝統織物など、ミャンマーは伝統工芸が盛んで、どんな紙に出会えるのか、期待しながら現地へ。旧首都のヤンゴン空港から国内線に乗り、さらに田園地帯を車で走ること2時間、着いたのはビンダヤという町です。当時ビンダヤには紙漉きが5軒ありましたが、若い姉妹が漉いている場所に案内されました。

　紙の原料は、ミャンマー語でショービンと呼ばれていて、麻の木を意味するそうです。ビンダヤそばのシャン高原に自生していると教えてもらいました。ネパールのロクタ紙やタイのサーペーパーとは雰囲気は異なるものの、やはり東南アジアらしい、原料が見える素朴な紙です。ちなみにミャンマーの紙に似た雰囲気なのは、ベトナムやラオスの紙ですね。

　姉妹が漉いているのは、90センチ角の紙だけ。聞くとお土産の傘用に漉いているから真四角なのでした。ふたりは私のことを日本からやって来た紙漉きと勘違いしたようで、しきりと日本の漉き方を教えてほしいと言います。困りながらも、落水と、糸を入れて漉く方法、そして現地の山肌が赤土だったので、それを入れて漉いてみてはどうだろうと伝えました。

　この言葉通りに漉いたものが、後日私たちの元に届きました。これらが記念すべき、ミャンマーから日本に正式なルートでやって来た最初の手漉き紙です。しばらくは傘用の紙とその3種の紙でしたが、その後日本に合わせた60×90センチのものと、漆を塗った紙にも挑戦してくれました。みなさんご存じの通り、ミャンマーは現在、国軍のクーデターによって混乱状態です。姉妹と連携してどんどんいい紙を漉いてもらいたいという希望もいまは叶わず、一日も早く正常化することを願っています。

白い紙が傘の紙、茶色い紙は漉いた後に漆を塗ったもの。

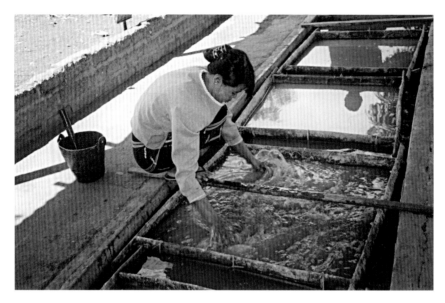

傘に貼るため、真四角の簀桁で真四角な紙を漉いていた。

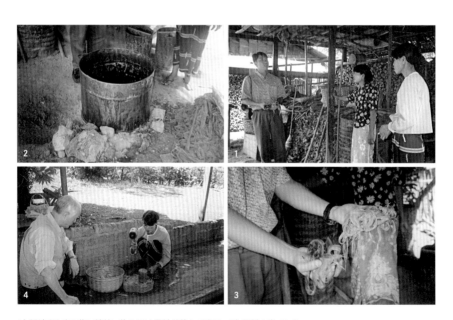

1）紙漉きをする若い姉妹。後ろには原料が積んである。2）原料を煮ている。
3）煮上がった原料。4）煮た原料を叩く。左はその作業を見る花岡さん。

1) 乾いたら紙を剥がして完成。2) 四角い紙の表面に糊を塗っているところ。これを傘に貼る。
3) 漉き場。しゃがんでかがみ込むように紙を漉く。4) お土産用の紙傘になる。傘に貼った後、色を塗る。

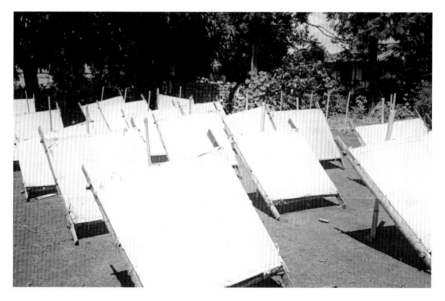

漉いた紙が天日干しされている。真四角な紙なのがわかる。

# 刺繍ペーパーほか

行きたいと思いながら、まだ行けていない国のひとつが
インドです。とはいえ扱い始めたのは比較的早い時期で、
2000年頃から。ドイツ・フランクフルトで開かれる見本
市「ペーパーワールド」で見つけることが多いのですが、中
にはインドのメーカーの方が「紙の温度」を訪れてくれたこ
とがきっかけで、取引が始まったところもあります。

インドで手漉き紙をつくる場合は、原料にコットンリンタ
ー（綿の種子に生えている短い繊維）や古紙を使ったものが
多いようです。コットンリンターを手漉きしたインドの紙は、
独特のふんわりと柔らかな質感でありつつ、素朴な風合いが
特徴的です。

「紙の温度」にあるインドの紙は、加工を施したものが大
半です。インドには成熟した織物の文化があって、紙の加工
会社は繊維産業の産地の近辺にあることが多い。繊維の加工
技術が、紙にも活かされているということだと思います。素

朴な紙に繊細な刺繍が施された刺繍ペーパー、多種多様なエ
ンボス（型押し）もありますし、きらめく粒状に盛り上がっ
た箔を施した粒エンボスペーパーはほかでは見たことがあり
ません。金色に染めた紙に起毛加工（フロッキープリント）
で絵柄をつけたり、スクリーン印刷で発泡剤を刷り、加熱し
て発泡させたりと、加工のバリエーションは本当に豊富です。

手作業がいまなお残っていることに加えて、これだけ複雑
な加工をしていても人件費が抑えられるためリーズナブルと
いうのも魅力です。ひとつのメーカーがプリントも染めもし
ているところもありますし、エンボス加工を専門にやってい
ると思っていた会社がピカピカのラメ加工紙をつくったりも
します。メーカーの多くは海外向けにつくっていて、アメリ
カ市場を狙った会社と、ヨーロッパ市場を狙った会社に大別
できます。前者はどちらかというと大味で、私たちは後者を
得意とする会社の紙に魅力を感じています。

写真左から刺繍ペーパー（2色）、
レインボーの箔がポコッと盛り上がって加工された粒エンボスペーパー（3色）。

すべてインドのエンボスペーパー。ベースとなる紙にメタリック色などをスクリーン印刷で
ベタ刷りし、その後エンボス加工を施すものも多い。

写真左から起毛加工（フロッキープリント）したもの（3柄）、発泡プリントしたもの、
スクリーン印刷で絵柄を刷ったプリントペーパー（2種）。

# 手漉きフルールペーパー

中国からヨーロッパに手漉き紙の製法が伝わったのは12世紀のこと。フランス中南部のオーヴェルニュ地方に、1326年からその製法のまま紙を漉いている工房「ムーラン リシャル ド バ（Moulin Richard de Bas）」があります。

原料となる綿布（衣料などに使われていた木綿のくず）を細かく刻み、庭の水車とつながった杵で24時間叩いて、繊維の状態に戻します。和紙のようにトロロアオイなどのネリ（繊維の分散を助けるもの）を用いないため薄く漉くことはできず、ある程度厚みを持ったものになります。この工房では無地のものも漉いていますが、ご紹介したいのは「フルールペーパー」です。

フルールはフランス語で草花のこと。ご覧のように、白い紙に色とりどりの花が一面に舞っています。ところどころシダの葉が散っていたりして、そこはさすがフランスのセンスの良さを感じます。工房の目の前にある花畑で毎朝摘んで、

それを入れているんです。フルールペーパーを漉くのは夏季限定、この地方の季節の風物詩になっているそうですね。この工房は花畑などを含む施設を公開していて、15世紀に建てられた建物もあるそうです。創業当時の14世紀は、製紙は門外不出の技術でした。そのため技術流出を防ぐために従業員が出られぬよう、門の外から鍵がかかっていたそうです。また退職後も、7年間はこの村から出られなかったそうですから、いかに製紙技術が貴重で秘密に包まれていたかがうかがえます。

フルールペーパーは「紙の温度」でも人気です。51×61センチのものを、求めやすいように四ツ切にしたり葉書サイズにしたものもあります。私もとても好きな紙のひとつで、2014年の「紙の温度」の年賀状はこのフルールペーパーでつくりました。1枚1枚、入っている花が異なって、なんとも贅沢なことをしたものですが、大変好評でした。

フルールペーパー。画用紙くらいの厚みがある。

# 手染めマーブル紙

マーブル紙は、比重の重い液体に絵の具を垂らして、専用の棒や筆で描いた模様を紙に写し取る技法でつくられます。ヨーロッパでは17世紀頃からつくられていたといいます。大理石（Marble）のような模様からこの名が付き、クジャクや猫の目などさまざまな模様があります。

フランスのマリー・アンヌさんのマーブル紙は、ずいぶん印象が異なります。彼女は正統な模様を学び、その技術を充分に修得した上で、オリジナルでモダンな模様をつくり出したのです。型にはまることなく紙いっぱいに広がる模様は、自然を愛するマリー・アンヌさんだからつくれるものだと思います。そして彼女独自の技法に「ダブルパッセージ」というものがあります。これはふたつの異なる模様を重ねてつくるので、奥行きのある表現が可能となります。金色を用いることもあり、それはなんとも豪華な仕上がりです。ヴェ彼女の工房には、これまでに2回うかがっています。

ルサイユ宮殿にほど近い趣のあるお屋敷が、その当時の彼女の工房でした。2度目に「紙の温度」の社員と赴いた時、マリー・アンヌさんの感性と技術で、日本の四季の風景を表現したマーブル紙をつくってくださいとお願いしたところ、快諾してくれたのです。「真っ暗な夜空に浮かぶ夜桜……。昼間とはまた違う色や表情を見せます。その美しさにはっとします」「川面にはかなく散る桜の花びら、花筏……。散りゆく姿までをも美しいと感じる日本人の心」（春）。「エメラルドグリーンやブルーの清々しい色を放つ川、活き活きとしたその流れ、ずっと眺めていたい夏の景色」（夏）。「色づいた紅葉がみせるさまざまな赤、オレンジ」（秋）。「雪山と川のせせらぎ。静と動が入り乱れる、生き続ける冬の姿」（冬）。

これらの言葉をもとに、次ページのマーブル紙をつくってくれたマリー・アンヌさんの感性に、我々は喜びの声を上げ、感謝するばかりなのです。

ダブルパッセージ模様のマーブル紙。

上）春をイメージしたマーブル紙。
下）夏をイメージしたマーブル紙。

上) 秋をイメージしたマーブル紙。
下) 冬をイメージしたマーブル紙。

# ペーストペーパー

ヨーロッパには、38ページのマーブル紙以外にも、伝統工芸として息づく紙の加工技術があります。ここでご紹介するペーストペーパーもそのひとつで、16世紀半ばに生まれたと言われています。ペーストは「糊」を意味します。糊の役割をする小麦粉やコーンスターチなどに水溶性の絵の具を混ぜて紙に塗り、乾燥する前に刷毛や棒などで模様を描く技法です。

ベルギーの「アクートデディエ」という工房は、このペーストペーパーが得意です。姉妹ふたりの工房で、彼女たちとはフランスの「サロン」と呼ばれる見本市で出会いました。初めて見た時、まず驚いたのは色の多彩さです。ニュアンスカラーと言いましょうか、たとえばブルーとグレーを混ぜたような色は、日本にはないものです。ふたりとも色に関しての探究心が強く、こちらの要望に応じて絶妙な色を作り出してくれるのも大きな強みです。加えて、縞の間隔を不揃

いにしたり、縞と曲線を組み合わせたりと、図柄に関しても芸として息づく紙のセンスの良さを感じます。時に奇抜なデザインもありますが、センスの良さと色使いの巧みさによって、それも魅力にしてしまいます。ヨーロッパの人が日本人にはない感性を持っていると思うのは、こういう時ですね。写真にある大輪のバラの紙は、簀の目模様が入った紙に色を塗り、糊入りの絵の具でスクリーン印刷しています。模様を付けない色無地もあり、色数も豊富に揃います。1枚1枚手づくりのため、まったく同じものはできません。また、見本帳もないので、色に関しても現地で会ってやりとりするものの、同じ色を出すのはなかなか難しく、そこは苦労する点です。アクートデディエの紙は、ルリユール（フランスの製本技術）の見返し部分に使ったり、額装にも人気です。

ペーストペーパー。写真左からペーストを刷毛や棒で掻いて模様を入れたもの（3種）、
スクリーン印刷でペーストを刷ったタイプ（2種）。

エンボスや箔押しがされた、ターノフスキーのプリントエンボスペーパー。

## プリントエンボスペーパー

かわいさを生む高い技術とデザイン力
プリントペーパーのトップランナー

◎ イスラエル

　ターノフスキー社は1940年にイスラエル・テルアビブで設立されました。プリントペーパーやグリーティングカードといった紙製品以外に、テキスタイルやギフト用品も扱っている大きな会社です。毎年新作を発表していて、大人向けからかわいいものまで、多種多様なデザインが揃います。「紙の温度」では、その中からかわいらしいものを選んで入れることが多いです。と言っても色使いは繊細ですし、エンボス加工が施された立体的な紙などは完成度が高く、大人も手に取りたくなるようなものです。フランクフルトの見本市に毎年出展していて、世界を相手にしていますから注文ロット数が大きいんです。1柄5000枚と言われるなかで、なじみの担当者にあれこれ交渉して数を抑えてもらったり。それもできるだけ多くの柄をみなさんに届けたいからです。

44

紙幣古紙が入った紙幣入り手漉き紙。

## 紙幣入り手漉き紙

この1枚でいったいいくら分？
大きな紙片が入っていると楽しくなります

　原料にお札の古紙を混ぜて漉いている紙をご覧になったことはありますか？　案外、世界のあちこちで漉いているのですが、お札とはわからないほど細かく断裁されていることが多いです。そんな中、イスラエルのイズハル・ニューマンさんの紙に入っているお札は大きくて、文字や数字が判読できるものもあるほどでした。彼は新潟の門出で和紙漉きの修行をして、楮とともにイスラエルへ帰国、日本で学んだ手漉きを母国で行っています。

　とても真面目なニューマンさんは、帰国後も楮の刈り取り時期になると親方のところに来て手伝っていました。ところで大きかったお札が、回を重ねるごとに小さくなっているのを残念に思っていました。ビーター（叩いた原料を水と一緒に攪拌する機械）の性質が良くなったのか、それとも政府関係からもっと細かくするように指示されたのか……。日本向けのものだけでも大きくしてくれないか、何度もリクエストしたところ、熱意が通じて紙幣のしっかりと入った紙が入荷しました。

樹皮紙

繊維をひたすら叩いてつくる
中南米からやって来た原始的な紙

青と茶の樹皮紙。

　中米の紙も「紙の温度」にはあります。と言っても、ホンジュラスからやって来たこの「樹皮紙」は漉いているのではなく、樹木から剥いだ樹皮の内側を水にさらして柔らかくし、棒で叩いて延ばして乾かす、それで終わりです。繊維をひたすら叩くと、まずは紙になるのだということが、樹皮紙を手に取るとよくわかります。その歴史は古く、石器時代にはすでに存在していたと言われています。なんの木なのかは皆目わからないのですが、漉いた紙とも、またテキスタイルとも異なる独特の質感があって、建築やインテリアデザイン関係の方にとても人気でした。この紙をつくっている会社は、天然素材やリサイクル素材を用いた建築資材や家具、テーブルウェアなどを扱っていて、ニーズをよくわかっているのだと思います。茶系統のアースカラーや紺、青、グレー系など、10色ほど再入荷を待っているところです。

コーヒーペーパー。粒々と黒く見えるものがコーヒーのカス。

# コーヒーペーパー

コーヒー豆だって紙になる
届いてすぐは香り付き

ホンジュラス

こちらも前ページと同じくホンジュラスからやって来た、古紙原料にコーヒー豆の外皮を混ぜてつくられた手漉き紙です。分厚くてゴワゴワした、素朴な紙です。

ホンジュラスのコーヒー生産量は中米1位と言われ、世界でも有数のコーヒー大国ですから、こういう紙がつくられるのでしょう。　紙として大きな特徴があるわけではないのですが、届いた紙の梱包をほどいたら、ふわっとコーヒーの香りがしたんです。紙になって、ホンジュラスから日本まで長旅しても、香りが一緒に届いたことが面白くて、記憶に残る1枚です。「紙の温度」で置いているコーヒーペーパーは画用紙くらい分厚いタイプで、少しデコボコがあり素朴な風合いの紙です。　残念なことに値段が高騰してしまい、今は継続を見合わせています。

47

マニラ麻やポカサを原料につくられています
ボコボコした質感をいかして

# ポカサペーパー

フィリピンは、もともとは紙の産地ではありませんでした。マニラ麻やフィリピン雁皮と呼ばれるサラゴ、桑科のポカサなど、紙の原料となる植物は生育しているので、後発的に紙をつくるようになったようです。「紙の温度」で〝白段〟という名前で置いているのは、マニラ麻とポカサが原料の紙です。ハンドメイドだと思われるボコボコした紙で、現地で買い付けました。かなり分厚い紙です。

壁紙に使うという方もいましたし、招待状を手づくりするのにこの厚さと風合いがいいと気に入る人も多くいます。ほかには、ダルマやお面、花瓶といった張り子細工のベースに使う人が増えました。いま張り子用の紙（古紙ベースの柔らかな厚紙）がなかなか手に入らなくなっていて、みなさんこの紙に目を付けたのだと思います。上から和紙を貼るためのベースとしてだけでなく、そのまま色を塗ってもいいですし、なにも塗らずにプレーンな形状を楽しむのにも向いています。

張り子づくりの要領で、ポカサペーパーでつくった花瓶。
ドライフラワーを飾ったり、形状を工夫すればペンたてにも。

ポカサペーパー。大きな凹凸が表面全体に。

# 韓紙・張紙房

良質の楮と確かな技量がマッチして
名人が漉く紙はやはりいい

韓国

楮100％で漉かれた張紙房のプレーンな韓紙（上）と、
手切りする部分に透かしの線が入ったこより原紙（下）。

日本に製紙の技術が伝わったのは610年、朝鮮半島からだったと『日本書紀』に記録がのこっています。日本の紙を和紙と言うように、韓国の紙は韓紙と言います。良質の楮が採れた韓国で盛んに行われた手漉き紙は、日本以上に減退の一途をたどり、一時期は韓国全体で5軒ほどしかないと言われたほどです。現在はその文化を取り戻すべく、奮闘しています。38度線近くにある「張工房」は、日本の人間国宝に当たるものに指定されている、張容薫さんの工房です。以前は別の場所だったのを、上質の楮を求めて冬の寒さ厳しいこの38度線近くに工房を移しました。日本でも名人と呼ばれる人は原料もいいものを使いますが、張さんも非常に良質の楮を使っています。正統派の紙漉きで、いい紙をつくる方です。息子さんがこよりの作家ということもあり、こよりのための紙も漉いています。「紙の温度」では、こよりに手切りする前の原紙を置いていて、いまは鮮やかな赤の原紙だけがあります。

50

# プリント韓紙

ハングルや紋様がプリントされた韓紙。

韓国

韓国の東南部、慶尚北道にある安東は、いまも韓紙づくりが行われている場所として知られています。ハングルや漢字、甲骨文字などがプリントされた紙は、韓紙工芸に使われます。韓紙工芸とは韓国の伝統工芸のひとつで、小さな箱から小机や箪笥といった家具まで、さまざまな生活雑貨を韓紙でつくります。最盛期は13世紀から18世紀にかけての朝鮮時代と言われています。現地ではいまも人気の手工芸でこのプリント韓紙はそれ以外にも、韓国料理店の店内装飾やメニューの表紙などに用いるのに重宝されています。日本でも韓紙工芸を楽しむ方はもちろん、他にカゴなどに和紙を貼り、柿渋で仕上げる "一閑張り" の紙として利用されることもあります。余談ですが、韓国はお隣の国にもかかわらず言葉が壁となり、やりとりにいつも苦労していま
す。そのたびに、近くて遠い国なのだなと実感します。

## タパ

南の国の素朴な樹皮紙
人生の節目にはいつもこの紙が

タパとは、南太平洋地域で伝統的につくられてきた、原初的な樹皮紙のことです。ハワイでは「カパ」、サモアでは「シアポ」と呼ばれ、フィジーでは「マシ」または「マシ・ケサ」とも呼ばれます。マシは、タパの原料であるカジノキの現地名でもあります。私はこれらを総称して「南の国の紙」と言っています。

樹皮紙は、以前はインドネシアで最も多くつくられていたのですが、途絶えてしまいました。46ページで紹介したホンジュラスの樹皮紙と比べて、タパはもっと薄く仕上げます。使うのは樹皮の内側の白い靭皮繊維だけで、レースほどに薄く延ばしたものを、繊維を縦に揃えて2、3枚重ね合わせて水で湿らせたものを、さらに折りたたんで叩き続けると、繊維がからみあって大きな1枚になります。そしてクズなどのでんぷんを接着剤としてつないで、反物のように仕立てます。かな

丹念に叩いて、水に浸して柔らかくします。それを小槌で

りの重労働ですが、タパづくりは女性の仕事なのだそうです。それを衣服に使うので、樹皮紙ではなく樹皮布と呼ばれることも多いです。初めての子ども（特に男の子）が産まれたときは、出産後すぐにタパでくるんでお祝いするといいますし、伝統的なウェディングドレスも、お葬式で棺を覆うのも、タパ。冠婚葬祭や人生の節目に使われる、神聖な紙といえます。

男性のふんどしに使うこともあるそうです。晒して白く漂白し原料そのままの色がでている未晒しと、つくりかたを読んでもわかる通り、樹皮そのものがあります。つくりかたを読んでもわかる通り、樹皮繊維を叩いてつくっているものなので、断裁しないときれいな長方形にはなりません。晒した白いタパに模様を施したものは、観光みやげの定番にもなっていて、そのまま飾って楽しめます。絵付けには木からつくった、タパ専用の茶や黒の塗料が使われます。モチーフや島や地域によってさまざまあり、ひとつひとつに意味が込められています。

未晒しのタパ（上）と晒して漂白した白いタパ（下）。

叩いて粘って結着させる
禁止されてもつくり続けられた紙

# アマテ

メキシコにもユニークな樹皮紙「アマテ」があります。ホローテというイチジク系の木の樹皮を剥いで干し、石灰と木炭を溶いた水に長時間浸けて柔らかくしてから叩いて乾燥させるのが、伝統的な製法です。繊維状にするのではなく、叩くことでホローテから出る粘りで原料を結着し、シート状にします。樹皮紙の中でも、メキシコ特有のつくり方です。

有史より広く使われていましたが、16世紀にスペイン帝国に征服されると、アマテは生産を禁じられました。ですが山岳部などでつくられ続け、20世紀半ばからはメキシコ先住民による手工芸品として再び注目され、観光みやげでも目にするようになっています。前ページのタパや、このアマテといった南の国の紙は、その存在を知りませんでした。樹皮紙を研究している坂本勇さんという方が教えてくれたことをきっかけに、いろいろな国の樹皮紙を知るようになりました。面白い紙がまだまだ世界のあちこちにあることに、いつも驚か

されます。

原料であるホローテそのままの色が出ている茶色いタイプ、晒して漂白した白いタイプ、その両方の原料を混ぜて叩いてつくっている白と茶のミックス、さまざまな色に染めた原料を叩いて結着させてできたカラフルなものや、色をつけた原料を格子状にし、それを叩いて結着させて紙にしているタイプなどさまざまなものがあります。白と茶のミックスは広葉樹のきれいな木目のようにも見えますし、メキシコらしいカラフルなアマテは「とにかくかわいいからほしくなる」というお声をいただきます。そのまま飾ったり、テーブルマットにしたり、いろいろな用途を楽しんでいただいています。

◎
メキシコ

54

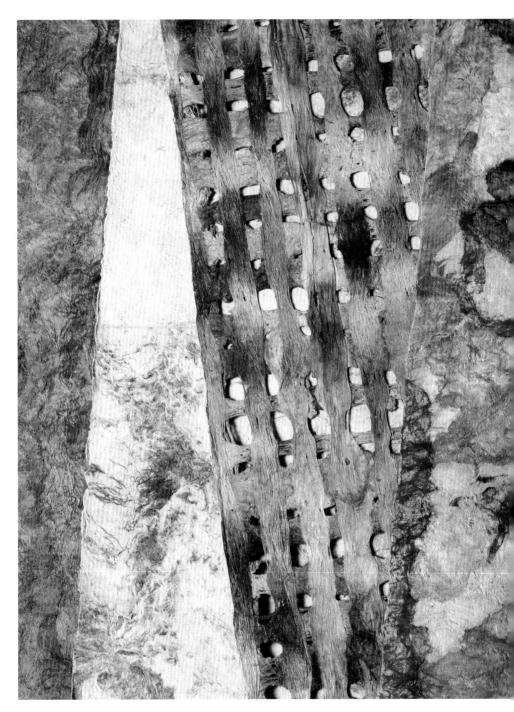

すべてアマテ。写真左から未晒しの茶色いアマテ、白と茶ミックス、格子状のアマテ、
多色でカラフルなアマテ。

天然でこんなにキラキラ光ります
見る人を魅了する不思議な1枚

# 金の繭の紙

金の繭の紙。よく見ると繭がたくさん連なっているのが見える。

インドネシア

　金色に光るこの紙は、なんと繭からできています。しかも着色したのではなく、天然の色なんです。２００５年に開催された愛知万博（愛・地球博）のインドネシア館の内装に、金色に光る繭の紙が使われているという新聞記事を見つけて、すぐに見に行きました。よくこんな色が天然で出せるなと感心したのを覚えています。本当に黄金色に輝いていました。ギラギラではなくキラキラと光るその紙をすぐ仕入れて、すでに売り切れてしまったのですが、「こういう紙があった」ということでご紹介します。インドネシアに生息するクリキュラという蚕の繭で、繊維が取りにくいため織ることができず、スライスなどの加工をして１枚１枚広げた繭を紙に貼りつけて、シートに仕立てたようです。日本には金色に光る繭からつくった絹糸製の着物があるようで、やはり「金」は人を魅了する、特別な色なのだと思います。

56

ペーパーの語源になったと言えばこれ
書家に人気のにじみ具合

# パピルス

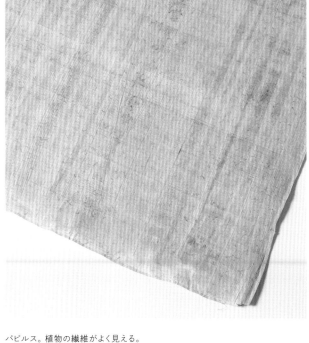

パピルス。植物の繊維がよく見える。

◎
エジプト

「紙の起源」と言われるパピルスは、古代エジプトでパピルスという草からつくられました。ペーパー（paper）の語源でもあります。古代の聖書は、パピルスかパーチメント（68ページ）に記されていました。パピルスはカヤツリグサ科の一種で、スライスして粘り気が出るまで叩いてシートにします。繊維を一度分散させ、絡み合わせてつくるものを「紙」と定義するので、パピルスは厳密に言えば紙ではありません。いまでもエジプトでつくられていて、意外と書家の方たちに人気です。繊維に沿って墨がにじむのが面白い味になるそうです。私の紙の先生である宍倉さん（76ページ参照）が、つくってみてはとパピルスの株を分けてくれたのですが、いくら叩いてもくっつきません。そうしたら、暑い国の植物なのだから熟成させて腐らせないといけないと宍倉さんが教えてくれました。こういうことは本には書いてなくて、実地の経験があるからこそわかるものだと再認識しました。

# プリントペーパー

イタリアのロッシ社は、プリントペーパーの分野で世界を牽引しています。1931年に、ルネサンス発祥の地であるフィレンツェで創業しました。1990年代の終わりに初めて行ったフランクフルトの見本市で出会って以来のお付き合いです。

ルネサンス時代からの伝統的な柄からモダンなものまで豊富に図柄があるのが魅力で、伝統的な柄の場合はその色使いの巧みさが際立ちます。カラフルなものもあれば、同系色のグラデーションもあって、どれも実にセンスがいい。

また、その柄にあった加工を施すのが本当に得意で、たえばタンポポの綿毛のような繊細な柄に、レタープレス（活版印刷）を用いたりします。このひと手間が、綿毛に立体感を与えます。オフセット印刷ではこうはいきません。ハート柄はレタープレスにさらに箔押しして、シンプルだけれども贅沢な1枚となっています。さらには心臓、脳みそ、ドクロ

といった驚きのパターンもレタープレスしていて、脳みそ柄でラッピングしたギフトを渡したら、相手はどんなにびっくりすることでしょう！箔押しづかいも巧みで、てんとう虫柄の場合は赤はオフセット印刷、その上から胴体の星部分と顔が箔押しされていたり、ミツバチ模様では、蜂の繊細な翅や胴体、そしてお尻の縞模様などに金箔があしらわれています。

ロッシ社は伝統ある会社です。創業から築いてきた技術を活かしつつ、新しいことにチャレンジし続けています。それがモダンなデザインなどに反映されているのだと思います。シンプルでそぎ落とされたデザインが多いのは、男性の兄弟がオーナーだからでしょう。伝統と革新という、一見すると相反するもののどちらも尊重する姿に、彼らの意気込みを感じます。

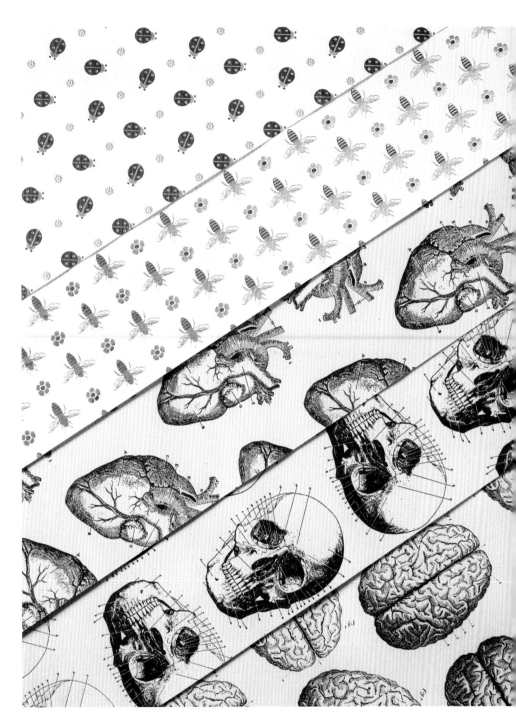

ロッシ社のプリントペーパー。上から順に箔押し加工が入ったてんとう虫柄とミツバチ柄、
レタープレス（活版印刷）された心臓柄、ドクロ柄、脳みそ柄。

# 手染めマーブル紙

伝統的な模様を伝統的な手法で
マーブルペーパーらしさが凝縮されています

ジャンニーニは、イタリアのフィレンツェで最も古くからあるマーブル紙の工房です。「紙の温度」では数多くのマーブル紙を扱っていますが、ジャンニーニは一番古くからのお付き合いです。38ページの説明と重なりますが、マーブル紙は、比重の重い液体に絵の具を垂らして、専用の棒や筆で描いた模様を紙に写し取る技法でつくられます。ヨーロッパでは17世紀頃からつくられていたといいます。大理石（Marble）のような模様からこの名が付き、クジャクや猫の目などさまざまな模様があります。元々は1枚ずつ手染めでつくられたマーブル紙ですが、現在は印刷でマーブル模様を再現する紙が増えていて、手染めしてつくる工房は減る一方。フィレンツェでも数軒が残るだけのようです。

そんな中、1856年創業のジャンニーニは、ルネサンスの時代から育まれた技法を継承し、手染めでつくっています。現在は六代目のマリアさんが工房を切り盛りしています。

日本にもジャンニーニのマーブル紙のファンは多くて、以前は来日して百貨店などで実演していたほどです。クジャクの羽のような模様の「ピーコック」や、名称の由来でもある大理石模様の「マーブル」など、伝統的な図柄を得意としています。図柄は同じでも絵の具の色を変えると印象が変わるのもマーブル紙の面白さ。櫛やブラシや棒といった道具でこれらの模様を紙に写し取るのですから流石です。絵の具がゆらゆらと動く瞬間の模様を紙に写し取るので、同じものはありません。

また、紙の地色がクリーム色のものと地色が茶色のクラフト紙とがあります。伝統的な図柄だけでなくイタリア人らしい奇抜なものも手がけますが、クリーム色のものは温かみのある仕上がりに、クラフト紙だとアンティーク風の仕上がりになるのも見どころのひとつです。

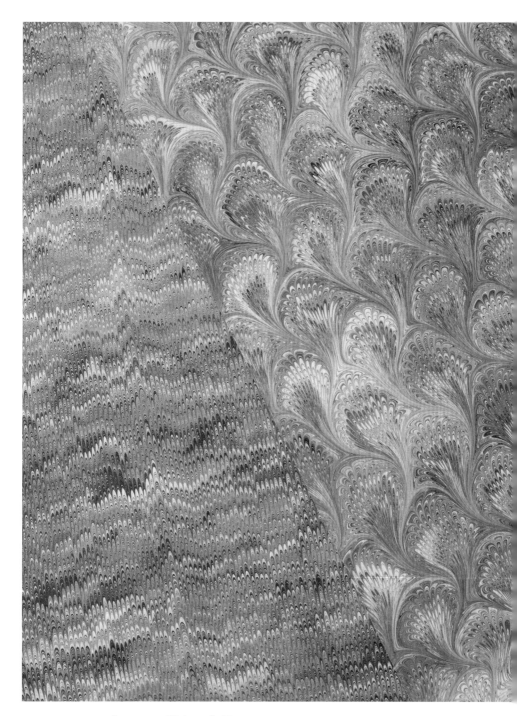

ジャンニーニの手染めマーブル紙。

アンティークローズ色の手漉きコットンペーパー。

# コットンペーパー

イギリスでも、つい最近まで手漉きのコットンペーパーをつくっているところがありました。伝統的な製法を守っていた会社で、私たちはフランクフルトの見本市で会う機会が多かったのですが、残念なことに廃業してしまったそうです。アンティークローズとセージの2色あって、アンティークローズは岩肌のような色で、もう一点はちょっとくすんだミントやセージの色でした。自然を感じさせるその色が気に入っていたのですが、彼らが漉くのを辞めたとなると、イギリスに手漉きで紙をつくるところはもうないのではないかと思います。1798年に紙抄きの機械が、1840年には木材パルプの製法が発明され、ヨーロッパにおける紙の歴史は大転換しました。高品質の紙が大量生産できるようになりました。ですがひとつの国から手漉き紙の文化が消えてゆくと、なんとも寂しく思います。

白いTシャツから生まれる白い紙
用途に合わせてサイズいろいろ

# コットンペーパー

折り紙サイズのメモパッドになったコットンペーパー。
これらの色すべてが1冊に。

カナダ

　カナダは手漉き紙が盛んだったわけではな
く、近年になって手がける工房が出てきたと
いう印象です。「紙の温度」には、モントリ
オールにある「サンアルマン」という工房の
コットンペーパーがあります。紙をつくる際
に化学薬品を用いないことをモットーにして
いて、白い紙をつくるときには白いTシャツ
を材料にし、青い紙をつくるときにはデニム
を材料にしているそうです。最近、日本では
コットンペーパーの人気が高まっていますね。
墨ののりがいいので書家の方が求めていくこ
ともありますし、水彩画や版画、カリグラフ
ィーに使うという声も聞きます。葉書サイズ
や細長いものもあるので、インビテーション
カードやカレンダーを手づくりするなど、い
ろいろな用途に使えるのではないでしょうか。
メモパッド（上写真）になったコットンペー
パー以外に、四方耳付き紙もあり、とても風
合いがよいです。おしゃれなパッケージにも
注目です。

63

# スカイバーテックス（スキバルテックス）

アメリカ製の擬革紙です。ベースとなる紙に着色し、エンボス加工などを施すことで、まるで革かと見まごう紙になります。この紙とは、「カルトナージュに使うスキバルテックスは置いてないの?」というお客さまからの問い合わせがきっかけで出会いました。カルトナージュは、紙や布で箱などにデコレーションを施す、フランスの伝統工芸です。「SKIVERTEX」というブランドで、フランスの伝統工芸で使うのだからフランスの紙だと思い込んで探したのですが一向に見つかりません。ようやく探し当ててたらアメリカの会社だったとわかり、どうりで見つけられなかったわけです。英語だとスカイバーテックスなのですが、私たちはスキバルテックスとフランス流の読み方にしています。

擬革紙はカルトナージュ専用ではなく、本の装幀をはじめチョコレートやワイン、香水のパッケージなどに広く使われる高級紙ということも、出会ってからわかりました。なによ

り、さまざまな国のパスポートの表紙に使われています。アメリカの工場へ視察にも行ったこともあります。シリンダーに革の模様の型を取り付け、プレスと樹脂の含浸を同時に行っていました。

いま「紙の温度」には20柄あります。ベーシック、豚革、スタンダード、しぼ、石目、エピ、オーストリッチ、ニトロリン、とかげ、クロコダイル、イグアナ、ハンマード、メタリック、ディンプル、イリデッセンス、織目、かごめ、ヌバ、ビキュアナ、カンブリックです。これだけの革のバリエーションがあることも驚きですが、これだけのスカイバーテックスを店頭に揃えているお店は世界でもうちだけだと思います。

色の展開がそれぞれにありますから、合計100アイテムは超えます。アメリカ本社から来た人がその量にびっくりしていたほどです。カルトナージュはもちろんのこと、フランス額装や製本、さらには折り紙用にと買っていく人もいます。

◎
アメリカ

柄は写真左からクロコ（2色）、イグアナ（2色）、ニトロリン（2色）。

# 草木染め亜麻紙

アメリカには紙漉きの伝統があったわけではありません。若い人が手漉きの魅力を知って、自分たちもやろうと工房をスタートさせることが多いようです。ケイヴペーパーもそのひとつで、アーティストの要素を持った人たちによって、1994年にアメリカ・ミネアポリスに誕生しました。

メインで漉いているのは麻の紙で、ベルギー製の亜麻を原料にしています。染めるのも自分たちでしていて、紙の白い部分をのこした藍染やくるみ染めといった草木染めを得意としています。このほかに柿渋染めにも挑戦しています。和紙の草木染めとはやはりワイルドな印象が違いますね。どこかワイルドで、スケールの大きさを感じさせます。均一に染めるだけでなく、ムラのような細かい模様や大きく大胆な模様に染めることもあり、1枚として同じものがない染め紙です。彼らが染め紙につけた名前は、黒のような濃い緑に染めたものは「Monsoon＝季節風」、彼らのこの紙の説明には「この豊か

な青緑色は、砂漠に甘美な命を吹き込む夏の終わりの雨の季節を表現しています」とあります。また強い黄土色の紙の名は「High Noon＝正午」、説明には「南西部の夏の日のように強い太陽に焼かれた、素朴で立体的な黄色いこの紙は、手漉きの亜麻紙に何度もざくろ染料を刷毛染めしてつくった」とあります。「Petrichor＝雨が降った時に、地面から上がってくる匂いを指す言葉」という名がついた紙があったりと、彼らのアーティスト性がこういったところからもよくわかります。

彼らの紙は、かなり前から置いています。と言うのも、「紙の温度」の開店間もない頃にこの紙を扱いませんかと持ってきたアメリカ人がいて、もちろんと引き受けたところ、それがケイヴペーパーの人だったのです。当時は古着のデニムを原料にしたコットンペーパーもつくっていました。

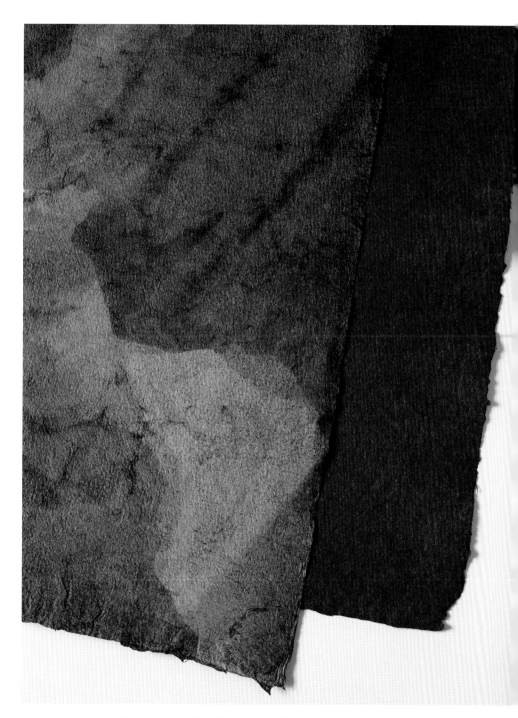

ケイヴペーパーの亜麻紙。写真左はインディゴ（藍）染め、右は柿渋で染めたもの。

# パーチメント

写真上がヤギ皮のパーチメント、下が羊皮のパーチメント。

アメリカ

　パーチメントは、パピルス（57ページ）に次いで開発された書写材料として知られています。日本では「羊皮紙」と言いますね。羊や山羊などの獣皮を石灰で晒してから磨き、滑らかで光沢を持ったこのパーチメントが誕生したのは紀元前2世紀ごろのこと。小アジア（現在のトルコ）からヨーロッパにかけて普及しました。欧州で12世紀に紙づくりが始まってからも、高級な書写材料として使われていたそうです。こちらもパピルス同様、厳密に言えば紙ではありません。「紙の温度」にあるのは、アメリカのものです。おそらくアメリカでたった1軒のパーチメント工房です。非常に高価なものですが、カリグラフィーの先生方に人気があります。おいそれと使えないかも知れませんが、そもそも高価なパーチメントを有効かつ美しく使うために生まれたカリグラフィーだからこそ、書いてみたいというお気持ちなのだと思います。

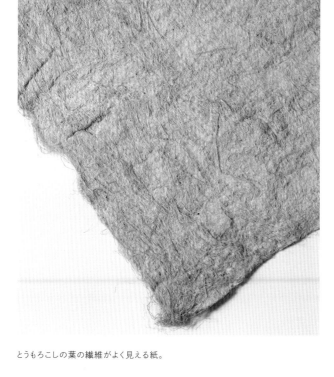

とうもろこしの葉の繊維がよく見える紙。

コスタリカ

# とうもろこしの葉の紙

乾燥すると緑色の葉がカーキ色に
リサイクル精神に富んだ試み

コスタリカからやって来たおもしろい紙の原料は、とうもろこしの葉です。とうもろこしから紙をつくるという発想が、まず日本人は思いつきません。おそらく葉を叩いて、溜め漉きするのだと思います。黄緑色の葉が乾燥することでカーキ色になって、なんともワイルド。コスタリカの紙はそのほかにも、バナナの茎の繊維をベースにして、くずココナッツ、オフィスのリサイクルペーパーと花の茎、印刷所の廃棄紙、コーヒー豆の皮を入れてつくったものなどを置いていました。さまざまなリサイクル素材で紙をつくろうという試みだったのだと思います。これらの紙は、1990年代後半にニューヨークの会社から取り寄せました。ただただユニークな発想に惹かれて入れたものの、残念ながら用途もなく終わってしまいました。実用的でなくても面白そうな紙があると聞いたら、とにかく見てみたくなってしまうのです。

# 手染めマーブル紙

ブラジルでマーブル紙？　ヨーロッパからどうやって南米に伝わったのか、不思議に思う人も多いのではないでしょうか。このマーブル紙は1973年生まれのレナート・クレパルディさんがつくっていて、彼はお父さんがイタリア人でお母さんが日系ブラジル人です。それならお父さんから技法を教わったのかと思いきや、実は独学で、書籍から学んだ努力家です。日本にも住んでいたことがあります。

マーブル紙をつくり始めたのは2002年で、すぐに自作のマーブル紙を手に店にやってきました。そのときからの付き合いです。

彼のマーブル紙は、先に紹介したマリー・アンヌさん（38ページ）とも、伝統的なイタリアの工房であるジャンニーニ（60ページ）とも、趣が異なります。伝統的な技術と現代のデザイン感覚をミックスさせてつくることに、彼はおもしろさを見いだしていると言います。また、通常は水彩絵の具を

使うのですが、彼が使うのはアクリル絵の具で、マットな質感を生むと同時に、耐久性も高めています。また、マーブリングする紙も、ヨーロッパでは白や生成りなど淡い色の紙が一般的ですが、彼は濃い色の紙を使い、絵の具にはパールを使ったものが多く、力強い模様が際立ちます。躍動感にあふれた、立体的なマーブル紙です。画家で博物学者のジョン・ジェームズ・オーデュポンが1827年に刊行した『アメリカの鳥』という超大型の図鑑があります。この複製本が日本で制作された際、見返しにこの手染めマーブル紙が使われ、クレパルディさんはとても誇らしげでした。原本はアメリカ人が出版した本で最も価値があるといわれてきて、複製版も4巻セットで300万円を超える貴重かつ希少な本なのです。

近年クレバルディさんは、マーブリングの手法を活かしたアート作品にも、熱心に取り組んでいるようです。

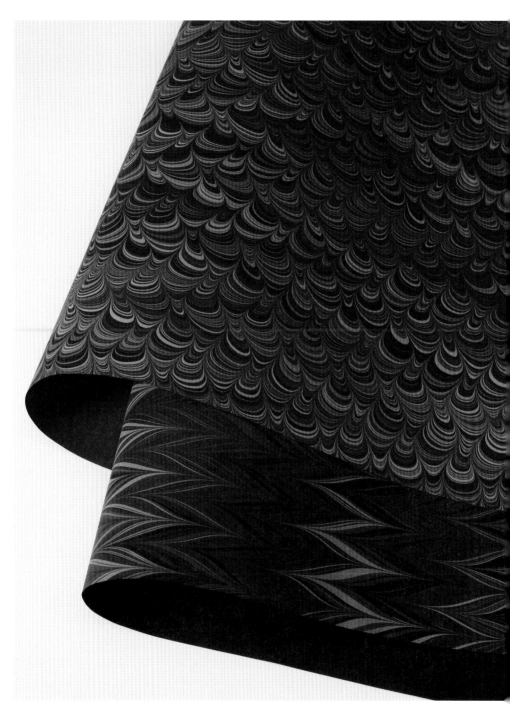

ブラジルでつくられているマーブル紙。原紙に濃色の紙を使うことが多い。

# クラア・アマゾンの紙

日本人が技術指導して誕生しました
新たな仕事が紙から生まれる喜び

原料の植物繊維がチラッと見えるアマゾンの紙。

ブラジル・アマゾン

クラアはアマゾンに生育する植物で、パイナップルの仲間でインディオたちがロープに使ってきたそうです。この紙は、168ページで紹介する金刺潤平さんが国際協力機構の技術専門家として現地に派遣され、技術指導して生まれたものです。アマゾンは熱帯地域で、多種多様な植物がたくさん生息しています。

金刺さんは、アマゾンの砂漠化防止と貧困層の人々の生活向上にという思いから、アマゾン流域各地の住民に声をかけ、それぞれの村にある草や植物系農産廃棄物を持ってきてもらい、紙をつくり続けました。その中で成功したのが、このクラアだったのです。村の人たちは、身の回りにある植物から紙がつくれること、仕事が生まれたことに、喜びを覚えたことでしょう。新たな希望をもたらした、プレーンで素朴な紙です。金刺さんはブラジル以外にも精力的に海外に赴き、アジア各国や欧州でワークショップを開催したり、ウズベキスタンでは古都サマルカンドのシルクペーパーの復元復興にも尽力しています。

72

## エレファントペーパー

紙漉きの工程を象がお手伝い
物語が内包されている面白さ

原料チリが少し見え、厚みのあるエレファントペーパー。
色つきもあり、写真左から白、黄色、赤、茶色。

スリランカ

象の紙とはどういうことかと思いますよね。もちろん、象が原料なわけではありません。象の糞が原料に含まれているんです。日本にも馬糞紙という厚紙がありますが、あれは麦藁などを原料にしていて、見た目から馬糞と名付けられているだけで、糞が入っているわけではありません。対してこちらは本当に糞入りです。汚いものをイメージするかも知れませんが、まったくそんなことないので安心してください。象が藁や草を食べ、消化されて糞になるまでの工程は、そのまま洋紙の抄紙の工程と同じなのだそうです。それを古紙と一緒に漉いています。繊維が残った、素朴な紙です。ある時動物園でこのような紙を売っているのを知って、「これは面白い！話題になるだろう！」と探し出しました。最初の取引先がやめたあとも根気強く探し、新たなご縁を得ています。大きな特徴があるわけではありませんが、こういうストーリー性を持った紙を知ると、やはりお店に置きたくなるものです。

麻紙

麻だからこその張りがある手漉き紙
技術の確かさと豊富な知識、そしてユニークな発想から生まれる

上2枚は型を用いた透かし紙。
茶色は未晒し、その下の白は晒した麻紙。

ドイツ

ドイツ人のガンゴルフ・ウルブリヒトさんがベルリンで漉いている、麻の紙です。彼は母国の製紙会社で技術者をしていましたが退職し、来日して1年かけて和紙の産地を訪ね歩きました。私はそのときに出会っています。熱心に和紙のことを勉強して、その後帰国して工房を設けました。器用な人で、流し漉きも溜め漉きもできるし、洋紙と手漉きのどちらも充分な知識を持っている。この麻の紙は、和紙にならった漉き方をしています。ヨーロッパの人は、ふつうこんな風にきれいに漉けません。こんなに均質でなく、もっとムラが出てしまいます。和紙を漉けるガンゴルフさんだからできることです。

型を用いた透かし紙もつくっています。矢印をパターンにしたものと、カフェテーブルの天板のエンボス模様を写し取ったものがあります。発想がユニークですね。世界で手漉きに携わる人は、ご自分なりのこだわりに忠実で、ユニークな方が多いです。

# ホイルペーパー

あなたのはどんな柄ですか？
キラキラ輝く華やかさが秀逸です

非常に細かいエンボスで模様が表現されている。

この本にも綴じ込まれている、キラキラ輝くホイルペーパー。何色の、どんな模様が入っていたでしょうか？　紙の地色と同色の模様が浮かび上がって、織物のようですよね。

石目、ぐるぐるの渦、唐草風、アラベスクなど、「紙の温度」には常時10種類は揃っています。ドイツ本国やヨーロッパでは大変人気のある紙で、定番の模様以外にも、クリスマスやバレンタインといった季節限定の模様も豊富につくられています。色もターコイズブルーやオレンジといった鮮やかなものから茶色や濃い緑のような落ち着いたものまで幅広い。目を凝らして見てみてください。とても細かい線が刻まれているのがおわかりいただけると思います。この線が、さまざまな角度からの光を反射して模様となり、浮かび上がっているのです。ラッピングに、オーナメントづくりにこの紙を使ったら、一気に華やいだ雰囲気が生まれます。「紙の温度」で毎年飾っているクリスマスツリーにも、オーナメントとして大活躍しています。

# 紙のことならなんでも教えてくれる人
# 植物を愛する宍倉佐敏さんのこと

　河原に穴を掘って漉くブータンの紙、工房の近くの花畑から草花を摘んで一緒に漉くフランスのフルールペーパー、南の国のいろんな樹皮紙、象の糞が入っているスリランカの紙……。世界にはおもしろい紙が本当にたくさんあることが、ここまででおわかりいただけたと思う。それぞれの紙の原料や漉き方や加工方法などの違いにも触れたが、「紙の温度」にある万を超える紙のすべてにそういうデータがあり、そして増える一方なのだから気が遠くなる。

　漉いた紙を見て、原料がなにかと聞かれてもちんぷんかんぷん。大勢の人はそうだと思う。花岡さんはじめ「紙の温度」のスタッフはもちろん紙のエキスパートだけれども、それでもわからないこともある。そのときの強い味方が、宍倉佐敏さんだ。花岡さんが尊敬の念を込めて言う。「私たちの紙の先生です」。

　「和紙も洋紙も、手漉きも機械抄きも、わからないことは宍倉さんに聞けば即答してくれます。紙を見ればぱっと原料がわかるし、もとより植物そのものに関する知識が尋常じゃない。和紙を漉いている音を聞くのが好きで、しかも聞いているといい紙漉きかそうでないかわかるというんですから脱帽です」

　宍倉さんは1944年静岡県沼津生まれ。洋紙製造会社の「特種製紙（現特種東海製紙）」に入社して、総合技術研究所と資料館準備室で約40年間、製紙用植物繊維に関する研究をしてきた。定年退職後は「宍倉ペーパー・ラボ」を開設し、紙の繊維分析や調査研究、試作な

どにあたっている。会社員時代の前半は洋紙の主要繊維である木材パルプを、後半は画材洋紙やファンシーペーパーに関わる原材料の研究を主にしたという。

紙をつくるのに、植物繊維の研究は欠かせない。特に洋紙は、使用するパルプの種類が多い。樹種ごとの繊維の特徴を知ることで、目的に対して「どういう繊維をどういう風に使えば安価でいいものができるか」が判断できるようになる。

「ひたすら顕微鏡で繊維を見ました。たとえばアメリカのサザンパインという木は4種類あるんです。繊維にはみんな膜孔といって孔が空いていて、4種のサザンパインの膜孔の形状は、まん丸だったり楕円だったり、それぞれ違うんですよ。顕微鏡で拡大した繊維をスケッチして、ひたすら覚えました。植物の繊維と、紙になったときの繊維を見て、覚えて、この形状ならこの植物だと特定し、知識を蓄積するしかないですから」

だから商社など海外出張が多い人たちに木材チップを持って帰ってもらうよう頼んだりもしたという。「木材パルプ」とひとくくりにされることが多いけれども、ものすごくたくさんの木があることが、研究すればするほどわかっていく。これまでどれくらいの繊維を見てきたのか聞いてみると、「覚えてないけど、何万かな、何十万かな?」と、ものすごい数！

聞けば会社から木材パルプの研究をするように言われたとき、「世界中の、紙になる植物を全部見よう」と決めたのだという。それを覚えるのが自分の夢なのだと。でも夢は人に言うものじゃないから誰にも言わずに研究を重ねたという宍倉さんは、少年の頃から植物が大好きだった。いまも愛用している顕微鏡は、昭和10年代のもの。少年時代にもらったお下がりで、その頃から自然に触れ、拡大して覗いてスケッチしていたのだから年季が違う。

「それでもまだ、初めて見る植物があります」

そのときは、世界中の植物が載っている図鑑を見て、似ている繊維がないかを探すそう。

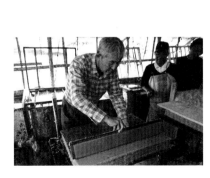

ネパールで日本の紙漉き方法を
現地のひとに紹介する宍倉さん。

洋紙の会社で働き、木材パルプの研究をしていた宍倉さんだが、和紙はいつ頃から触れていたのだろうか。聞くと木材パルプ研究3年目のことで、きっかけは海外だった。

「アメリカやカナダで技術研修をしたとき、多くの人から和紙についての質問を受けました。でも明確に答えられない。帰国したら和紙の勉強をしようと決めて、関東や中部の和紙生産地を訪問しました」

帰国後に岐阜工場に転勤したことも、和紙の勉強にうってつけだった。和紙を代表する産地である美濃まで、バイクで1時間。紙を漉く職人を訪れては手伝うと、とても喜ばれたという。「だってタダで力仕事するんだからね」

機械抄き洋紙と、手漉き和紙。同じ「紙」でも異なるふたつの世界を往き来することで、宍倉さんの知識は豊かで複層的なものになっていく。洋紙同様に和紙の繊維分析をして記録し、古い時代の製法や原料繊維の分析も行った。仕事を通じて大学の研究室や宮内庁、国立公文書館などに赴き、通常はお目にかかれないような国宝級の資料に触れる機会も多く得た。

洋の東西も、過去も現在も、紙と植物繊維を軸にしている宍倉さんにはすべてつながる。研究に留まらず、現場に精力的に出向き実地の経験も積んだから、頭でっかちでない判断が下せるし、さまざまな要素を総合的に比較対照できる。さらには畑で三椏を栽培して、自分でも紙を漉いている。

「洋紙が、紙の使用目的を重視して、叩解という工程を経て、繊維の性質を変えてつくられた『人工製品』だとすれば、和紙は、植物繊維が持つ特性をいかして、清らかな水とネリ剤の助けを借りて、繊維を自然なかたちに並べ替えた『自然製品』です」

宍倉さんにそう言われ、すとんと腑に落ちる。和紙は自然製品だからこそその風合いや質感がある。同じ原料でも、地質や天候で繊維の太さや長さが変わったりする。同じ産地でも、

宍倉さんの編著書。
右)『和紙の歴史 製法と原材料の変遷』
（財団法人印刷朝陽会刊）、
左)『必携 古典籍古文書 料紙事典』
（八木書店刊）

漉き手によって異なる仕上がりになる。それが大きな魅力であると同時に、原料や漉き方を特定することの難しさにもなっている。

「そのための比較基準となるものがないんです。だから文化財の修復などの際にも紙の特定が難しい。大学の研究室でも、どう教えたらいいかわからない。そういう状況をよく知る宍倉さんが私たちにお声がけくださり、試行錯誤の末に完成した見本帳があります」

花岡さんがそう言いながら見せてくれたのは、「繊維判定用 和紙見本帳」(発行・発売‥紙の温度)だ。この見本帳には楮、三椏、雁皮という主たる和紙の原料と、麻、そして竹を原料に漉いた紙が21種類入っている。繊維判定しやすくなるよう、楮でも茨城の那須楮と福岡の八女楮と異なる産地を入れたり、繊維を煮熟するときの薬材(木灰、ソーダ灰など)を変えて漉いたりしている。

実現するのに一番大変だったのは、「21種類の紙すべて、ひとりの漉き手が漉くこと。そして水質が異ならないよう、一カ所で漉くこと」。なんともハイレベルなお題だが、同一条件で漉かないと判定基準にならない。幸いにも、当時京都の黒谷で和紙を漉いていた林伸次さん(現、黒谷和紙理事長)が引き受けてくれた。そして宍倉さん指導の下、1年半かけて、製法についての詳細な記録とともに漉いてくれたのだという。そうして、紙の修復家、保存科学研究者、大学や大学院の研究室、博物館や美術館の学芸員といった人たちにとって、待ちに待った見本帳が完成した。宍倉さんが蓄積してきた膨大なデータの大事な一部が、手のひらにのるほどのこの小さな見本帳におさまっている。

花岡さんが力を込めて言う。

「本当に、『紙の人』です。五感すべてで紙を感じ取っているのだと思います。多くの人に、その存在を知ってほしいです」

宍倉さんのような人がいることが素晴らしい。紙の業界に、

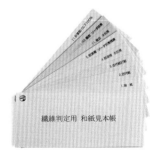

繊維判定用
和紙見本帳

宍倉さんの話を聞いていると、紙を知ることで歴史や文化が浮かび上がってくることがよくわかる。たとえば料紙（文書など文字を書くときに使う紙）にしても、中国は漢字だけだから筆の運びが速く、そのため紙が強くないといけない。対する日本は漢字と仮名文字があるから運筆が遅いため、紙に強度がなくても大丈夫。紙を漉くときに繊維の分散を助けるトロロアオイなどのネリを用いるのは和紙特有で、ネリによって、長い繊維のまま美しくて強い紙が漉けるのだとか。また宍倉さんは、文書など歴史ある紙を見ると、書いた人の地位や教養がわかるという。

こうやって話を聞くうちに、ふと不思議に思ったことがある。「紙」っていったいなんだろう？　初歩的すぎるけれども、思いきって宍倉さんに聞いてみた。

「どこからを紙とするのかは、人によって違うと思います。私の頭の中では、文字が書けたり印刷できるということが紙の条件ですね。でも、そうじゃない人もいるでしょう。たとえば以前、花岡さんと一緒にネパールに行ったのですが、バナナの繊維の紙があると現地の人が言うんです。その工房の設備を見たところ、私はそれは無理だと思いました。バナナの繊維から、文字を書ける紙をつくれるような設備じゃなかったからです。でも彼らは、シート状になっていれば紙だという。定義が違うんです」

なるほど！　これまた腑に落ちました。

「紙の温度」では社員教育の一環として、宍倉さんを講師に招いて勉強会を開催している。研究熱心なお客さまも、ときには一緒に参加するという。果てしない紙の世界にどっぷり浸かった人にとって、それは至福の時間だろう。紙を、植物繊維を、そして植物そのものを愛する宍倉さんの趣味のひとつが盆栽で、そのきっかけも「紙になる植物を育ててみようと思ったから」。どこまでも「紙の人」なのだ。

# 日本の和紙

# 藍絞り染め紙、紅花漉込紙 ― 月山和紙

雪深い地域ならではの「寒ぐれ」と「雪晒し」
それによって白くなる和紙の不思議さ

月山は「がっさん」と読みます。古くからある和紙の産地でしたが、戦後激減しました。現在では「大井沢工房さん（ぽ）」の三浦一之さんともう一軒が漉いています。三浦さんはサラリーマン生活をへて35歳の時に和紙の世界に飛び込みます。埼玉県小川で7年間修行したあと、月山和紙の土地である西川町に移住しました。西川町に「自然と匠の伝承館」が完成した1989年のことで、紙漉き職人を探しているという話を聞いてのことでした。

三浦さんは地楮（地元の楮）と高知産の土佐楮、茨城産の那須楮を使って漉きます。楮の木は北海道にはないので、東北地方が北限です。月山での和紙づくりの工程に「寒ぐれ」と「雪晒し」があります。寒ぐれは漉いた紙を冬の間雪の中に埋めて、天候が安定する3月すぎに掘り出します。雪晒しは、樹皮を取ったり煮熟したあとの原料を雪の上に並べ、天日に当てることを指します。そのとき紫外線が楮の色素を破

壊し、白くなるそうです。そして生成りの和紙は漉いたあともだんだん白くなっていくと言われていて、洋紙にはない独特の現象です。三浦さんは雪晒し、寒ぐれの後に天日板干しで仕上げます。

三浦さんは、東北で一番頑張っている人ではないかと思います。彼の紙を気に入って使っている日本画家もいます。素のままの和紙もいいのですが、紅花を漉き込んだ和紙が人気です。山形は紅花の産地で、それを使っています。以前はヤマブドウや筍の皮などの漉込紙も扱っていましたが、紅花に落ち着きました。厚みが数種類あり、厚いものは本の表紙や箱に貼ったりしてその表情を楽しめます。書道用に漉いた薄くて細長いものもあります。藍絞り染め紙は1枚1枚異なる表情が魅力で、タペストリーや暖簾に仕立てる方もいらっしゃいます。

山形・西川

82

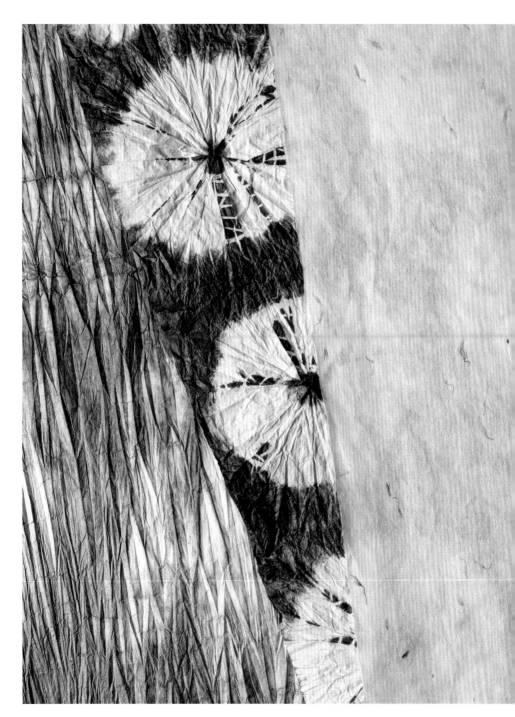

写真左から藍絞り染め紙2種、紅花漉込紙。
藍絞り染め紙はさまざまな技法で染められている。

# 拓本紙 ── 白石和紙

白石和紙は、伊達政宗の殖産奨励保護のもとで急速に発展して一大産業となり、重臣である片倉小十郎領内のお百姓の冬期内職として栄え、東北各地に供給していたそうです。かつて白石で和紙に携わる人たちは「かじの木会」と名乗っていましたが、それは楮にも種類がありその中のカジノキを使ったからで、それが白石の特色でした。この白石和紙は2015年に最後の工房が廃業し、歴史が途絶えかけたのですが、地元有志のみなさんによって継続しています。ご紹介するのは「佐藤紙子工房」です。紙子は紙衣とも書き、衣服や服飾品に仕立てる紙を意味します。戦国時代から続いた伝統的な紙子が消えかけたとき、呉服店を営んでいた佐藤忠太郎さん（故人）が、「和紙の着物を白石からなくしてはいけない」と、本業をやめて紙子づくりに傾注しました。そしてこんにゃく糊で強化した和紙に、版木の模様を写し取る「拓本」の技術を用いて、拓本紙をつくりました。佐藤さんが

所有する古い版木の中には模様がかすれているものもあって、時代を感じさせます。忠太郎さん亡き後は次男の奥さんである文子さんが工房を継ぎ、拓本紙をつくっています。色染めした紙に版木の模様を写し取るものが中心ですが、「紙の温度」では模様の部分を白で写し取ったオリジナルもお願いしています。模様が白くなっただけで、伝統的なものがモダンに見えてくるから面白いものです。軽く柔らかい紙子の特性は、衣服はもちろん、バッグや名刺入れなどにも向いています。

余談ですが、伊達政宗とは敵対していた真田幸村が、1615年の大坂夏の陣で討ち死にする前日に、五女を片倉小十郎のもとにひそかに送り届けました。その後4人の子女も白石城に迎え入れられます。その縁で片倉小十郎に真田紐が受け継がれ、東北に広まったのだそうです。紙のことを知ろうと調べると、思わぬ歴史的なできごとにたどり着くことがあって、それが私にとっては面白くてたまりません。

木版の凹凸を写し取って模様を入れた拓本紙。
色や柄は数多くあり、同じ柄での色違いなど多種多様につくられている。

## 西ノ内紙

関東で和紙といえばこの土地でした

透かすとわかる、白い紙の美しさ

高品質な原料・那須楮からつくられる西ノ内紙。
写真は未晒しのもの。

茨城・常陸大宮

私たち日本人にとって、和紙というと楮の紙を指すことが多いです。古来、障子や襖などの表具、古文書の一種である奉書など幅広く使われてきたからでしょう。地域ごとに楮の和紙の産地があって、その土地の名前で○○和紙と呼んでいました。関西なら杉原、東海なら美濃、そして関東では細川か、この西ノ内が「和紙」の代名詞でした。楮の中でも上質と言われているのが、茨城県大子町で栽培される楮で、「那須楮」と呼ばれるもの。品が良く柔らかい和紙ができます。大子町に近い西ノ内では那須楮を使っています。常陸大宮にある「紙のさと」の菊池さんが漉く西ノ内紙は、ムラがなくてきれいです。塵などなくて、非常に均質。手に取ったら、ぜひ光に透かしてみてください。ごまかしのきかない、楮の白い紙の美しさが実感できると思います。和紙を用いて作品をつくる人で「菊池さんの紙でないと!」という方は多く、材料の良さと、菊池さんの和紙漉きに対する真面目な姿勢が評価されているんですね。

86

紙の温度では、小川和紙の折り紙は60cm角と30cm角ともに28色揃う。

大きなサイズがきちんと真四角

折り紙愛好家から人気です

# 折り紙原紙

折り紙というと一般的には20㎝や25㎝角くらいのサイズですが、埼玉県小川町の「鷹野製紙所」では60センチ角という大きなサイズをつくっています。60×90センチの紙を抄き、そこから取れる最大サイズの60センチ角にカットしています。この大きさできちんと真四角に切ってあるので、折り紙愛好家の方に人気です。と言うのも大きな和紙から自分で真四角に切り出すのはなかなか難しく、みなさん苦労しているのです。昨今の折り紙は折り数が多く、厚みが出すぎない薄い紙が好まれるのですが、その点もクリアしています。そして近年は色付けした原料で漉く「先染め」の色紙をつくることが環境的に難しくなっている中で、鷹野さんは多色展開しており、その点でも貴重な存在です。古い歴史を持つ小川和紙ですが、機械抄きでは鷹野さんともう一軒が抄くのみとなりました。

# 流泉紙

クモの巣のように無数の糸が張りめぐらされている、とても不思議な紙です。この紙を漉いているのは、埼玉・小川町のすぐそばに「鶉堂」を構える新井悦美さん。子育ての傍ら、ひとりで紙漉きを始めました。いまから40年ほど前のことです。流泉紙という名前は、お義母さんの戒名「空祥雲流泉大姉」から頂いたそうです。こんなにユニークな糸入りの紙を漉くようになったきっかけは、ご主人の実家が機屋で、余った糸が捨てられているのがもったいないという気持ちから。

木枠に釘をたくさん打って、そこに糸を引っかけます。そして漉き、乾かして、枠から切り落とします。文字にするとこれだけですが、釘を打つのも、糸を張るのも、漉くのも、切り落とすのも、すべて手作業ですから気が遠くなります。

新井さんはとにかく和紙が大好きで、楮の畑も持っているほど。「こんなに手間がかかっている紙なのだからもっと値段を上げてもいいのでは」と言っても、「自分は紙を残した

いだけだし、漉いていられれば嬉しいからいいのよ」って。欲のない人です。

全判（60センチ×82センチ）以外に、丸型や四角型、さらには99センチ×147センチという特大サイズも漉いていて、これを1枚つくるのにどれくらいの時間が必要なのかと思うとクラクラします。私たちから提案して、柿渋を塗ったものもあります。この流泉紙は、インテリアに活用しがいがあると思っています。ランプシェードに仕立てたら光の漏れ方が独特になるでしょうし、タペストリーにもおすすめです。いま、この手法を用いた紙づくりは国内のみならず海外でも目にしますが、その元祖は新井さんです。「もったいない」という気持ちから生まれた、独創的な紙です。

染めたものや、糸の貼り方が違うものと表情はさまざま。

# 無添加和紙、漉き込み美術工芸紙、文庫紙 ——小川和紙

小川町にある「久保製紙」五代目の久保孝正さんは1982年生まれ。化学薬品や染色の勉強も熱心で、和紙の未来を考えている若手です。久保製紙は正統の小川和紙以外にも、いろんな種類の和紙を漉いています。無添加和紙はその名の通り、化学薬品を一切使わずにつくられています。楮の繊維を均一に水に広げるために用いるトロロアオイも、化学保存料不使用のものを用い、煮熟には地元のピザ屋さんからわけてもらった灰などを使っています。見た目になにか特色があるわけではないのですが、化学薬品を使っていないということは、言ってみれば「食べられる紙」なんです。

久保製紙では、楮紙を独特の色合いでムラ染めした染楮紙もつくっています。久保さんはこれを「漉き込み美術工芸紙」と名付けました。雲龍のような色とりどりの繊維で表面に模様を付け、時には金も含んだ豪華な揉み紙です。こんにゃく糊加工もしているので丈夫です。

もう1枚、文庫紙をご紹介しましょう。和紙人形の芯地にも使われる紙で、乾燥させるときに紙を貼りつける木の板目がそのまま写し取られています。板目の紙は全国にありますが、ここまで板目がハッキリしているということは、それだけ永く使われてきたということ。年月を経て木の乾燥が進んで、木目の凸凹がより強調されています。そしてこの板目はずいぶん大柄で、相当な大木から切り出した板だということが察せられます。

久保さんは近年、書道や版画用にドーサ引（にじみ止め）加工を始めたそうです。これまでドーサ引きをしていたひとが辞めたそうに、相談を受けたことがきっかけでした。本職の版画家や書家ならいざ知らず、趣味で楽しむ人が自身で好みの加減にドーサ引きをするのは、場所も必要ですしハードルの高い作業です。久保さんのチャレンジによって、困っていた人が助けられたことでしょう。

写真左から漉き込み美術工芸紙（2種）、無添加和紙、文庫紙。

# レース和紙

可憐な「レース和紙」をつくる田村智美さんは、生活消費財メーカーのデザイナーから和紙の世界へとやってきました。

私は田村さんがメーカーに勤務していたときに出会っています。東京藝術大学美術学部のデザイン科出身の田村さんは、休日を利用して和紙の産地を巡るほどの紙好きで、「いつか紙漉きになりたいんです」と話してくれました。そして30歳を目前にして退職し、最初は土佐和紙の産地である高知に7年間、次に埼玉県東秩父村へ。細川紙技術保持者だった鷹野禎三さんに弟子入りし、鷹野さんの工房「紙工房たかの」で和紙づくりに励みながら、就業後や休日の時間に自分の作品づくりも行いました。

「透かし」の技法を用いたレース和紙のアイデアは高知に行く前から浮かんでいて、高知でつくり始めたそうです。自らデザインした文様を型紙に彫って紗の布に張り、簀に縫いつけて漉くことで、透かし模様ができます。その図柄はという

と、更紗模様の小花や穂、クローバー、南天といった花模様から、雪の結晶やロボット、バラの花とトランプを組み合わせたもの、丸く漉いた和紙にマトリョーシカやフェアリーテイル、パレードなど楽しさいっぱいのものまで、デザインを学んできたからこそ生まれる素敵なものばかり。紙を漉くことに熱心な職人さんたちとは異なる感性を持っていると思いますし、それをかたちにする技量もしっかり身に付けています。

残念ながら鷹野さんが亡くなられ、田村さんは故郷の群馬に戻りました。いまは女子美術大学の非常勤講師もしていて、紙漉きについて教えています。そしてこちらから板締めなど染め和紙を依頼しながら、漉くための道具が調うのを待っているところです。

花と葉の紋様が透かしになった田村さんのレース和紙。

# 型染め和紙、民芸紙 ── 八尾和紙

富山の和紙の原点は、薬を包む紙です。「富山の薬売り」から、和紙が発展したのですね。越中和紙のひとつである八尾和紙は、いまは「桂樹舎」1軒だけが残っています。桂樹舎がつくる紙でよく知られているのが型染め和紙です。型染めは通常は布を染色する技法ですが、紙に用いるようになった背景には、創業者の吉田桂介さんと染色家の芹沢銈介氏との出会いがありました。芹沢氏は民藝運動の主要人物のひとりであり、吉田さんも大きく影響を受けたと聞きます。芹沢氏が沖縄の紅型（型染めの一種）に出会い、型染めをやろうと決意したときのこと。水洗いに耐える和紙を探し、吉田さんに相談しました。そこから型染め和紙の技法が開発されたそうです。

伝統的な模様に加えて、近年はモダンな柄も増え、若い人たちにも人気です。揉んでいるから丈夫ですし、耐久性もあります。そしてこんにゃく糊を塗って加工しているので、耐

水性もあります。自分で型染めをしてみたいという方に向けて、染める前の無地のものもあります。「紙の温度」では紙そのもの以外にも、名刺入れやノートブックなども置いています。

民芸紙（単色で染められた和紙）も色数が豊富です。桔梗色、檜皮色、ウグイス色、海老茶など和の色にもこだわっていて、どれもきれいに染まっています。揉んでいないものと揉んでいるものがあって、単色という点では同じでも、質感はずいぶん異なります。黒と赤は染めが一番出しにくい色と言われていますが、ここの黒はいいです。青みがかったりすることなく、漆黒に近づけている。この黒い民芸紙は、和傘に用いられることもあります。そのときは厚みを調整して漉いてもらいます。というのも厚みがありすぎると閉じにくいので、いい塩梅の薄さにお願いしています。

写真左は民芸紙（2色）、右は型染め和紙。色違いで染められた型染め和紙も多くある。

# 杉皮紙、野集紙、桜貝の紙 ── 能登仁行和紙

能登仁行和紙は、石川県輪島でつくられている唯一の和紙です。ド迫力の杉皮紙は、杉の皮の部分の粗い繊維を漉いたもの。堅い皮をほぐして溜め漉きすることで生まれる表情は、まるで大地のよう。もともと輪島は紙漉きのない土地でした。

初代の遠見周作さんが第二次大戦中に旧満州で竹の紙漉きを見て、自分もやってみようと思い立ちました。山には楮も生えているし、輪島は漆器の産地でそれを包むための和紙の需要があったことも追い風になりました。杉皮紙を漉くようになったきっかけは、製材所に捨て置かれている杉の皮を見たこと。雨に打たれた杉の皮の美しさに感動して、和紙にしようと決めたのだそうです。厚手で堅く、壁に掛けたりテーブルに置いたりするだけで存在感を放ちます。

遠見さんは杉皮以外にも山野草や野花、貝、もみがらなど、思いつくものをどんどん漉き込みました。和紙の歴史のない土地ゆえに、オリジナルな発想を活かしやすかったのかもし

れません。その大らかな精神を受けついだのが、遠見家に嫁いだ京美さんで、二代目として杉皮紙をはじめ、さまざまな紙を漉いています。杉皮紙はとりわけ重労働なのに、「紙漉きの家にお嫁に来たのだから絶やしてはいけない」と励んだ京美さんに感服します。草花などを漉き込む技法はいろんな土地にありますが、遠見さんの野集紙は摘んだ草花を乾かさずにそのまま入れるのが大きなポイントで、立体感があります。京美さんがつくり上げました。草花を生のまま入れるのは、現在はこの野集紙と36ページで紹介したフランスのフルールペーパーぐらいです。漉いているところを一度見せてもらいましたが、色とりどりの花が工房にいっぱいあって、とてもいい光景でした。創意工夫の精神は息子の和之さんも受けついでいて、桜貝や木の皮を入れて漉く模様紙などを意欲的につくっています。輪島の豊かな自然が紙に溶け込んでいて、思わず手に取りたくなります。

石川・輪島

96

写真左から杉皮紙 雲龍 茶とこげ茶。

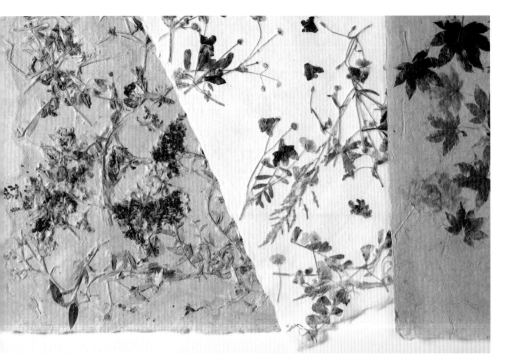

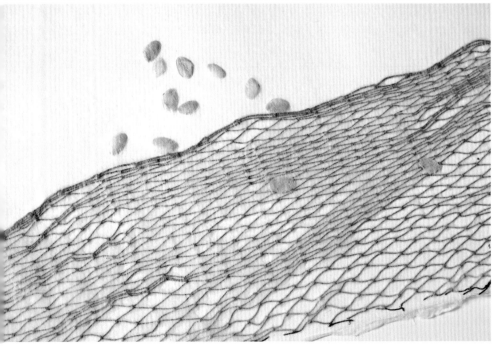

上）左右は未晒しの野集紙、中央は晒しの野集紙。花だけでなく紅葉のように
葉を入れたものもある。下）桜貝や網そのものが漉き込まれた、桜貝の紙。耳付き葉書に
桜貝が漉き込まれたものなども。

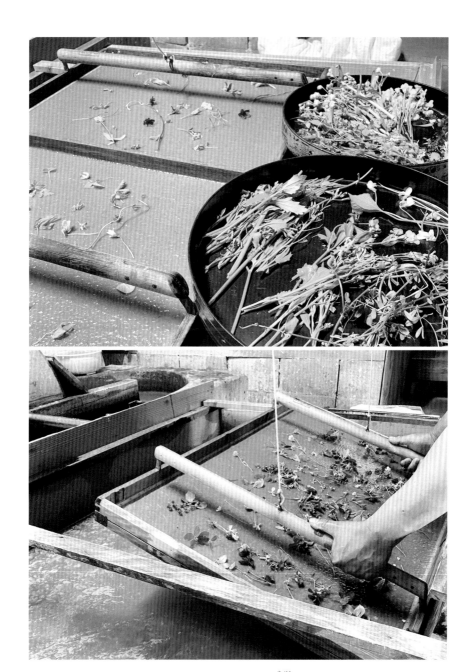

工房近くに咲く花や葉を摘み、それを生のまま、一度原料を流した簀桁の上に配置し、
さらにもう一度原料を入れて漉き込み、野集紙ができあがる。

千年もつ和紙の特性を名前にした紙
とても丈夫で水にも強い

# 悠久紙 ── 五箇山和紙

富山県五箇山と言えば、合掌造り集落が世界遺産に登録されていることで有名です。ここでいま和紙を漉いているのは、宮本友信さんが家族とともに運営する「東中江和紙加工生産組合」を含めて3軒です。宮本さんは広い楮の畑を持ち、その手入れに始まり、雪晒しを行い、漉き、製品になるまで、昔ながらの和紙づくりに取り組んでいます。そうやってつくったものを「悠久紙（ゆうきゅうし）」と名付けています。「千年を経てなお紙の色も墨の色も変わらない」と言われる和紙の特性をあらわしています。

この悠久紙は桂離宮や国指定重要文化財の古文書の修復などにも使われていて、名古屋城の本丸御殿でも復元修復に用いられているそうです。和紙としてはとても丈夫で水に強いのも悠久紙の特徴で、私たちが有松絞りの紙を試作したときにも使いました。有松絞りは名古屋の伝統工芸のひとつで、その技術を用いることで和紙の新たな絞り染めの織物です。

用途を見つけられるのではないかと考えました。そこで有松絞りの方々に相談したところ、はじめは「和紙には無理だよ」とけんもほろろだったのです。でも丈夫で水に強い紙なのでとにかく一度試してみてくださいと打診を続け、試作をしてもらい、強さを実感してもらいました。そうして完成したのが「有松絞り染め和紙」と「名古屋友禅型染め和紙」で、悠久紙があったから生まれた紙です。

未晒しの楮紙のほかに、くるみの葉やきはだの皮、ヒノキの皮などで染める草木染めもあります。また、未晒しの楮紙や草木染め紙を手もみした揉み紙もあります。ちなみに、揉んでしわを付ける手揉みの技法は、海外にはないものです。揉み紙に用いられる紙の原料は楮が多く、その繊維は強い上に柔軟という特性があり、それが手揉みに適しているからかも知れません。

左から悠久紙とくるみの葉でピンクに染められた草木染め紙。

# 有松絞り紙

いま30代の染色家・藤井祥二さんは有松絞りの次世代の担い手として精力的に活動されています。有松絞りは、「紙の温度」がある名古屋発祥の絞り染めの織物で、100ページに書いたように、店では紙にも活かしたいとずっと取り組んでいます。そんなこともあり、名古屋駅のそばで有松絞りの若手有志による展覧会が開催されていると聞いて見にいったのが、藤井さんとの出会いでした。面白かったので「紙の温度」でも展覧会を開き、オリジナル商品もつくりました。彼は紙のことも熱心に勉強していて、店によく来てくれるようになったんです。

有松絞りを海外に発信する活動の中で、ニューヨークで作品を発表したとき、その価値が伝わりにくかったと残念そうでした。日本ならではのものの魅力を伝えるにはなにをすべきかをいろいろ考えて、和紙の糸を使ったオリジナルの布を作品に取り入れ、それをニューヨークの同じ場所で展示し

たところ、飛ぶように売れたそうなんです。しかも初回より10倍の値段をつけたにもかかわらず、です。その貴重な経験をへて、彼のものづくりの方向性は明確になりました。染めるものは、布でも紙でもなんでもいい。そして絞りにとらわれることなく、モダンなデザインにも取り組み始めました。さまざまな会社と組んで、ニーズに合わせて自分の技術を駆使して染めることを活き活きとやっています。

「紙の温度」でも、ドイツから有松絞りをするために来日した河合デシリーさん（104ページ参照）と一緒に、季節に沿った大作を展示しています。展示作品以外にも、有松絞りの伝統的な技法「竜巻絞り」をアレンジした、ジグザグやダイア柄といった幾何学模様と絞り染めの有機的な表現があいまった作品など、布に染めるのは難しい、紙に染めるからこそできるパターンを用いた和紙をさまざまにつくっており

れます。

◎
愛知・名古屋

有松絞り伝統の「竜巻絞り」を応用し雁木模様を表現した藤井さんの有松絞り紙。

ドイツで出会った有松絞りに魅せられて
ポップな色使いが紙を彩ります

# 有松絞り紙

　102ページで紹介した藤井祥二さんとコンビを組んで活動しているのが、河合デシリーさんです。彼女はドイツ人で、アニメが大好きで日本に興味を持ったという現代っ子。大学でファッションデザインを学んでいた時に、有松絞りに出会います。欧米でも「タイダイ」として絞り染めは認知されていますが、「有松絞りならタイダイよりずっと豊富な表現ができる」と、大きな可能性を感じたそうです。

　そしてドイツでファッション関係の会社に就職してから、2008年に初来日しました。その時は短期間でしたが、もっと有松絞りのことをしっかり勉強したいと再来日し、現在に至ります。ほかの仕事もしながら、藤井さんと活動しています。ピンクや青といった鮮やかでポップな色使いは、やはり日本人とは違う感性を持っているなと思います。

　2022年から『紙の温度』に、2ヶ月ごとに違うテーマ

で、デシリーさんの有松絞り紙を展示しています。このプロジェクトでさまざまな色や自由なコンセプトを盛り込め、自分の世界観を忠実に表現できたと話してくれますが、布に比べると破れやすく、強度もない和紙を絞り染めするのはデシリーさんにとって初めての試みで、本当に成功するか不安だったと言います。それでも試行錯誤を繰り返し、納得のいくものができあがるようになり、「和紙だからこそ出せる色合い」があると、いまではお気に入りの素材となっています。

　和紙の魅力にはまってしまったデシリーさんの作品は、東京・銀座の老舗文具店でも展示されました。「東京の方や、東京を訪れる海外の方に、和紙の魅力を知ってもらえる機会になったら嬉しいと願いながらつくりました。そして『紙の温度』での展示を通して、西洋と日本のアートの架け橋となるべく、和紙を取り入れた作品をつくっていきたい」と語るデシリーさんを見ていると、こちらまで嬉しくなります。

和紙に有松絞りの技法を使って多色染めしたデシリーさんの有松絞り紙。

# 小原和紙

半流し漉きという漉き方の発見

流し漉きでも溜め漉きでもない

加納登茂美さんと恒さん夫妻のユニット「かのうともひさし」は、「紙の温度」からも近い豊田市で、土を入れたり色紙を流し入れたりと工夫を凝らした紙をつくっています。その背景には、「小原工芸紙」という紙があります。豊田市はもとは小原と言いました。藤井達吉氏（1881年〜1964年）という愛知出身の工芸家・芸術家をご存じでしょうか。彼は地場産業や伝統工芸の復興にも力を入れ、小原にも住みました。当時の小原で漉かれていた「森下紙」は、素朴で丈夫な紙で、柿渋を塗って生活用品や番傘などに用いる加工原紙でしたが、用途がなくなり廃れてしまうのを危惧した藤井氏が、「美術工芸紙」の制作指導をしたのです。紙以外に布や螺鈿なども使い、継ぎ合わせたものに絵の具で着色、そこに歌を散らすもので、和紙というより作品ですね。多くの職人さんが美術工芸紙の作家にシフトしました。

加納さんはその道を選ばず、紙漉きになりました。登茂美さんのお父さんが美術工芸紙をつくっていたので、料紙の技法はよく知っています。そして恒さんは土に詳しい。そういうふたりの持ち味を活かして、工房に近い土地の土や砂を入れて漉いたり、乾く前に水をかけて模様をつくる落水紙や、刷毛を用いて表情をつくったりしています。

ところで紙の漉き方は、日本は流し漉き、海外は溜め漉きが主流です。竹簧を張った簧桁に紙料を何度も流し込んで厚みを持たせていく流し漉きに対して、溜め漉きは金網を張った桁の上に紙料を一度に汲んで漉きます。私たちの紙の先生である宍倉さん（76ページ参照）が、そのどちらでもないものに「半流し漉き」があると名付けました。流し漉きでいちど汲んだときにすっと手を上げて水を打つ（捨て水と言います）。その、手をすっと上げた瞬間に紙が一層できている、その漉き方を指します。これを知った加納さんたちは「自分たちの漉き方はこれだ！」と合点がいったそうです。

◎ 愛知・豊田

落水模様が漉き込まれたり（上左）、銀箔が入ったり（上中）、色付き紙料に
落水模様をつけ金箔を散らしたり（上右）。下右は青い紙料で漉いた上に
白い紙料を漉き合わせ、それを指できゅっと寄せて模様付けした和紙。

# 生漉紙 奉書 ― 越前和紙

越前は和紙の産地の中でも特別です。この地区で言い伝えられている伝説に、「川上御前伝説」があります。継体天皇（507年～531年）が男大迹王と呼ばれていた頃、岡太川の川上に美しい姫君が現れ、村人に紙漉きの技術を丁寧に教えました。喜んだ村人がその名をたずねると、「この川上に住む者」とだけ答え、姿を消してしまいました。村の人たちは姫君を川上御前と崇め、紙祖神として岡太神社に祀り、紙漉きを生業として受け継いでいるのです。川上御前は越前のみならず日本の紙業界の守り神であり、紙に関わる者としては、なんとも羨ましい伝説です。

このような背景を持つ越前では、いまも多くの紙漉き工房が活動しています。岩野市兵衛さんは1978年に九代目岩野市兵衛を襲名、2000年に人間国宝に認定されました。そして今なお現役で漉いておられます。岩野家は代々「生漉奉書」一筋。「楮の繊維を、そのままの状態で紙に仕上げる

ということを信条に、ひたすら楮の紙を漉き続けています。奉書は主に版画用紙として用いられます。岩野さんの漉く和紙はとても丈夫です。版が重なれば馬棟で擦る回数も増えますが、生漉奉書は300回擦っても耐えると言われています。そして丈夫であると同時に、とてもきれいです。透かしてみても美しい。いい楮を使っていることはもちろん、紙になるまでの工程も非常にていねいです。まず原料の水洗いを念入りにしますし、流水を使います。これでチリがしっかり取り除けますし、セルロース以外の余分な成分も洗われます。国内だけでなく、海外の版画作家からも指名されるのがよくわかります。あのピカソも岩野さんの紙を愛用していたのではというエピソードもあります。浮世絵の修復版をつくる時の紙としても人気です。ほかに全国の神社などに奉納されている、日本刀を拭うための「刀拭紙」もあります。

岩野市兵衛さんが漉いた生漉紙 奉書（左）と刀拭紙。

# 大高檀紙 ── 越前和紙

宮中行事に使われる由緒ある紙
シワの高さを自在に操る技術

山崎吉左衛門紙業の大高檀紙。

福井・越前

檀紙は楮を原料とし独特なシワが入っている和紙で、シワの深さで大高、中高、小高と呼び分けます。歴史は古く、奈良時代にはすでに存在していました。武家社会の男性が使っていた紙で、庶民は使えなかったそうです。

山崎吉左衛門紙業はいま十代目が継いでいて、檀紙づくりの第一人者です。檀紙は命名の儀はじめ皇室での宮中行事に用いられていることからも、由緒正しい紙と言えます。シワが入っているのに書をしたためられるのかと思われるかも知れませんが、結納の時にも使われていますからそこは問題ありません。

檀紙づくりの機械化が進む中、いまも手作業を頑なに守っています。大中小と異なる紙の大きさがあり、山崎さんはそれぞれのサイズに見合うようにシワの高さを変えます。小さい紙に大きなシワは合わないからです。特殊な道具や手は用いず、刷毛一本で紙にシワを付けるというのですから驚きです。さらにシワの高さや見た目を調整する技術を持っている。門外不出の技なのです。

110

# 雁皮紙 無塩素7ミクロン ── 越前和紙

国産雁皮100％でつくられた極薄7ミクロンの雁皮紙。
この薄さでも艶があるのがわかる。

福井・越前

　7ミクロンの紙ってどんなに薄いか、想像つくでしょうか？　薬を飲むためのオブラートが20ミクロン。その3分の1ですから、手に取っても質量をまったく感じさせません。日本一、いえ世界一薄い紙です。「梅田和紙」の梅田修二さんが、自分の技術でどこまで薄く漉くことができるかに挑戦しました。原料は雁皮です。雁皮の紙はきめが細かく表面が滑らかで、楮や三椏と比べて光沢と艶を持っています。ですが栽培が難しく、自生している山奥まで採りに行かねばならない希少な原料でもあります。原料を調達するのも、漉くのも大変、イチョウの板に板干ししてはがすときにも破れてしまう。ものすごくロスの多い、前人未踏の紙です。でもなんとか紙にしたいという梅田さんの姿勢にしびれました。残念ながら梅田さんはその後廃業されてしまいました。紙が好きな方々に、こんな紙があるのだということ、そして漉いた人が日本にいるのだということを知ってもらいたくて扱っています。

# 打雲紙 ── 越前和紙

岩野平三郎製紙所は、越前でも大所帯の工房です。現在は四代目にあたる岩野麻貴子さんが、平三郎襲名を目指して励んでいます。麻と楮が原料の麻紙や、雁皮や三椏などを用いた鳥の子紙を漉いていて、麻紙は日本画用の大判を漉いています。

初代岩野平三郎さんは13歳で紙漉きを始め、多くの画家からの要望に応えて相応に漉き分け、多種多様な和紙の開発を行った方です。「雲肌麻紙」もそのひとつ。もともと麻紙は大麻や苧麻や楮からつくられた和紙で、奈良時代、日本でも多く漉かれていました。しかし平安時代以降は和紙の主原料が楮となり、麻紙は時代とともに廃れてしまいました。それを1926年に、麻と楮を主原料にした「岡太紙」、昭和初期に麻に楮と少量の雁皮を加えて新たな「雲肌麻紙」として復活させたのが、初代岩野平三郎さんです。紙の表面に繊維が絡まりながら雲状に見えることから名付けられました。日本画の和紙画用紙として使われています。

紙の天地に藍と紫が雲のようにゆらゆらとたなびいているこの紙は「打雲紙」と言います。鳥の子紙を漉いて、そこに藍と紫に染めた紙料を流し、簀桁を漉き舟に当てながら模様をつくっていきます。その加減が難しく、高い技術が求められます。打雲紙は平安時代からつくられていて、かな料紙に用いられてきました。室町時代には短冊にして、和歌会でも使われていたようです。当時の雅な雰囲気を、和紙が伝えてくれる。嬉しくなります。

ところでみなさんは、鳥の子紙は漉く原料によって名称が異なることをご存じでしょうか。雁皮100%のものは「特号」、雁皮と三椏の混合は「1号」、三椏100%は「2号」。三椏とパルプの混合は「3号」、マニラ麻とパルプの混合は「4号」と言います。なので「2号鳥の子」と言えば三椏100%のものだとわかるのです。

岩野平三郎製紙所でつくられた打雲紙。

# デザイン落水紙、引っ掛け和紙、透かし和紙 ── 越前和紙

伝統的な技法を用いて
花を咲かせたり、水玉模様を浮かび上がらせたり

◎
福井・越前

「柳瀬良三製紙所」は現在、良三さんのお孫さんである柳瀬京子さんとご主人の靖博さん、そして女性ばかりの紙漉きが切り盛りしています。薄手の楮紙といった王道の和紙もきれいですが、紅葉やイチョウ、笹の葉を漉き込んだもの、金箔を施したものなど、ひと手間加えた和紙に見どころ多いものがあります。花のようにも雪の結晶のようにも見えるかわいらしい「デザイン落水紙」には、越前らしい技法が用いられています。

まず、水をかけて模様をつくる「落水紙」で、これはまず簀桁で紙料をすくって紙を漉きます。その紙がまだ濡れているうちに上から水滴を垂らすと、その水の勢いで紙料に模様がつき、紙全体に穴があいたように仕上がります。

「引っ掛け」という技法もあります。先にベースとなる紙を漉いておきます。それとは別に金網状の型に原料の繊維を引っかけて、ベース紙がまだ濡れているうちにそれを上から重ね合わせます。引っ掛けて重ね合わせた原料は光沢感のある雁皮や、色付き原料を使っているため、紙の上に模様が漉き込めるわけです。

和紙技法としてよく知られている「透かし」も、柳瀬良三製紙所ではモダンな柄を採用し、光に透かすと模様が見えるという透かしだけでなく、一部が完全に穴が開くほど強く入れた透かし和紙もつくっています。

楮薄紙透かし水玉（4色）。

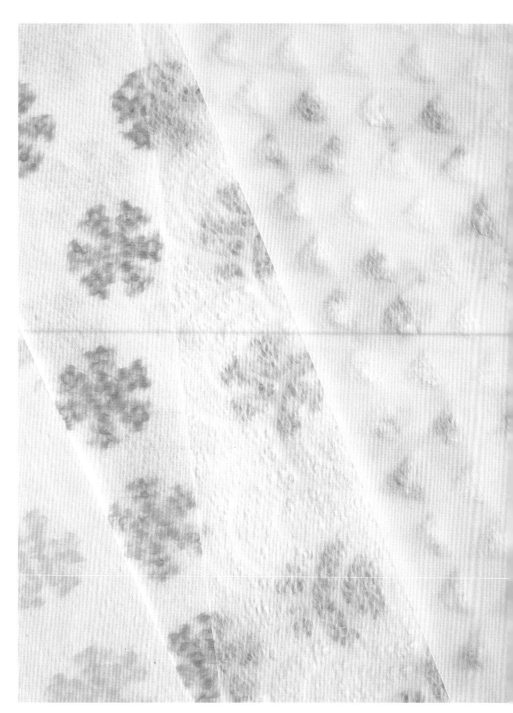

左から柳瀬良三製紙所の華やかな花模様が入った引っ掛け和紙（2種）、
落水紙、透かし和紙。

# 本美濃紙 ── 美濃和紙

伝統ある和紙の産地が一丸となって
価値あるものづくりの指標を示しています

和紙の産地と聞かれて「美濃」を思い浮かべる方は多いのではないでしょうか。良質の楮が豊富に採れる、長良川と板取川からの清らかな水を潤沢に使えるという恵まれた環境で、古く奈良時代から栄えてきました。江戸時代には高級障子紙としての評判が広く届き、江戸幕府にも納めていました。最盛期には紙漉きが5000軒あったと言われています。いまでは30軒ほどになりましたが、美濃和紙を後世にのこしていこうと、ブランド化にも熱心に取り組んでいます。独自の品質基準を設定し、その基準をクリアしたものが「本美濃紙」「美濃手すき和紙」「美濃機械すき和紙」と認定されます。品質基準を最も厳しく設定しているのが本美濃紙です。それらは、原料は大子那須楮（白皮）のみ、本美濃紙の指定要件を満たす伝統的な製法で製造されたものであること、本美濃紙保存会員であることなど。美濃は県外からの紙漉きも多くいる土地ですが、これまで本美濃紙と認定されたのは、み

な美濃の人たちです。いま認定を受けているのは3人で、私たちのところにあるのは「澤村正工房」の澤村正さんの本美濃紙です。京都の迎賓館に5000枚もの本美濃紙をおさめたことからも、その質の高さがわかります。15歳で紙を漉くようになって以来、80年近く続けてきました。その間、どれだけの美しい紙を漉いたことでしょう。「いい紙を漉く後継者を育てることも大切」と、お弟子さんに知識と技術を授けています。

本美濃紙の品質基準が記されたもの。

澤村正工房で漉かれた本美濃紙。

紙にはまだまだ可能性がある
そう感じさせるエネルギーが漉き込まれています

# 落水紙、マコモ紙 ──美濃和紙

Warabi Paper Companyの千田崇統さんが紙漉きになった
のは、ひょんなことから。岐阜生まれですが和紙になじんで
いたわけではなく、本人曰く「毎日飲んだくれていた」東京
での学生時代のあと、ロンドンへ。ですが都会での生活に疑
問を抱くようになった千田さんは、南米・ペルーへと向かい
ます。帰国後に見つけた仕事が、美濃での紙漉き体験指導で
した。しばらく働いた後、次になにをしようかと思案してい
たときに、廃業する紙漉き工房が後継者を探しているという
一報が入ります。迷わず志願して工房に通い始め、紙漉きの
面白さに目覚めます。そして無事後を継ぐことになりました。
先代から受け継いだ型を用いてつくる落水紙は非常に繊細
で美しく、技術も確かです。図柄も菊唐草、七宝、渦巻きな
ど、本人のワイルドな風貌と異なるそのギャップも面白い。
マコモを原料にしてマコモ紙も漉いています。マコモは出雲
大社のしめ縄や盆ござづくりに用いられる、イネ科の大型多

年草です。

千田さんはこれらの紙と並行して、作品づくりも行ってい
ます。土や竹炭を入れたり、楮の繊維を藍染してそのまま流
し込んだり、ものすごく分厚く仕上げるなど、私たちが思う
紙の範疇から飛び出している作品を見ると、紙はまだまだ可
能性があるなと嬉しくなります。

また、楮の栽培から収穫までしている「美濃市楮生産組
合」にも入り、ついに自分の畑も持ちました。さらには工房
裏の土地に「ワラビーランド」なる施設を建設中です。ここ
は「アーティストから子どもまで、自由にものづくりができ
る拠点」で、すでに完成した母屋は床壁天井すべて千田さん
の和紙が貼りめぐらされています。このワラビーランドは、
手仕事をし、助け合いながら自由に生きるペルーの人々の暮
らしを目の当たりにして、「いつか自分もそんな村をつくり
たい」と構想していたとか。スケールの大きな人物です。

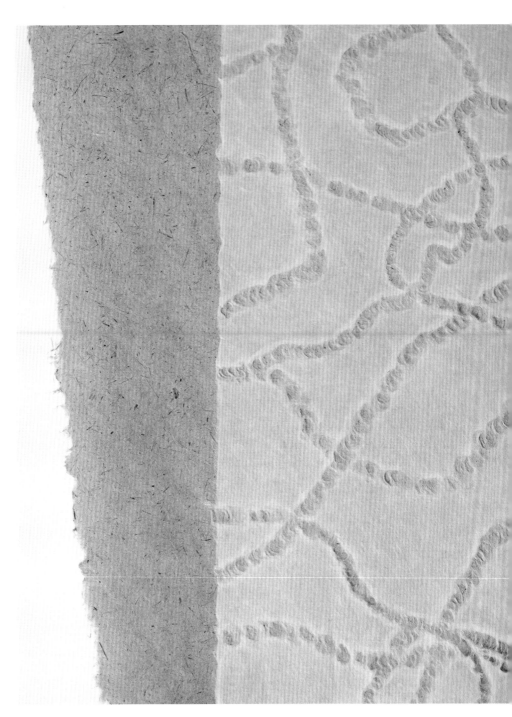

Warabi Paper Companyの千田さんが漉いたマコモ紙（左）と落水紙（右）。

# 味噌用和紙、うつし染め和紙──美濃和紙

「幸草紙工房」の加納武さんは表具の裏打紙などに使われる薄美濃紙が得意で、とてもいい紙を漉きます。その腕を見込んで「紙の温度」オリジナルの紙を漉いてもらっています。

「楮紙 味噌用」という紙です。きっかけは「紙の温度」のスタッフが料理教室で味噌をつくったこと。発酵させるためにふつうはラップフィルムで覆って密閉するのですが、材料にもこだわっているし昔ながらの製法で密閉でつくるのだから、適した和紙がほしいという経緯からでした。加納さんならつくってもらえるのではと依頼すると、快諾してくれたのです。食品に直接当たるものですから薬品は使わず、密閉するには薄い方がいい。そして原料に含まれるリグニンなどはカビの原因となるのでできる限り取り除いてもらいたい。そのために、原料を洗う時間が通常は2時間程度のところを、味噌の紙は11時間近く洗うのです。洗う時間を長くすることでリグニンなどが取り除かれ、セルロースだけ、つまり楮の繊維だ

けになります。美濃はきれいな水が豊富にあり、流水で洗えることも有利にはたらきました。そしてなにより、手を抜かずに11時間洗うことを実践してくれた加納さんがいたからこそ、生まれた紙です。今回は最初から薬品使用はNGでしたが、たとえば苛性ソーダなどの薬品を使って洗うと、手早くきれいにはなるけれども、紙が弱くなってしまいます。誕生の経緯から味噌用と謳っていますが、もちろん書を書いたりと別の用途にも使っていただけます。

もうひとつの「うつし染め」は、生の葉っぱや花びらを小槌で和紙にたたきつけて、色とかたちをそのまま写し取った紙です。たたいたら葉っぱや花は取り去るのですが、藍の葉の緑も露草の青もそのまま紙に写っています。芝桜もあります。65×98センチ以外に一筆箋と和封筒、葉書もあります。こんな紙でメッセージをもらったら、嬉しくなってしまいますね。

藍の葉を使って染めたうつし染め和紙（上）と、味噌用和紙（下）。

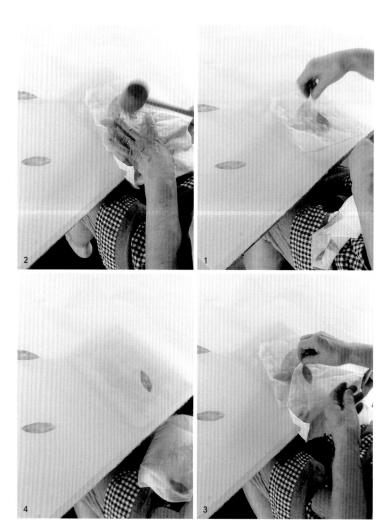

1）藍の葉を写す工程。まず和紙の上に薄い布を敷き、その上に藍の葉をのせる。

2）藍の葉の上にさらに布をかぶせ、木槌で上からたたく。

3）何度かたたいたら上布、藍の葉、下に敷いた布をすべて取り去る。

4）藍の葉を和紙に写すことができた。

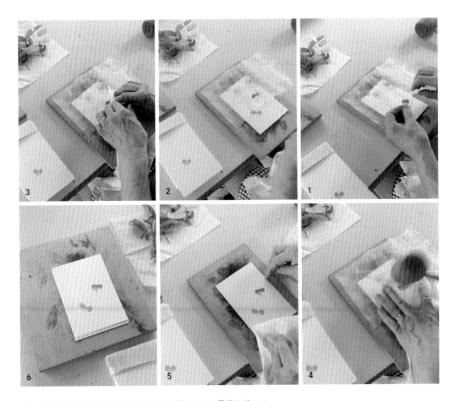

1)、2)手漉き和紙葉書の上に布を敷き、摘んできた露草を並べる。
3)並べた露草の上からもう1枚布をかぶせる。4)布の上から木槌で露草をたたく。
5)上布、露草、下に敷いた布をすべて取り去る。6)完成。露草の置く位置はいろいろと。

露草や藍の葉、芝桜花の
うつし染め和紙葉書。

# 伊勢擬革紙

殺生禁物を背景に生まれた擬革紙
口伝ゆえに消えかけた紙が復活しました

かのこ絞り（左）、さざなみ絞り（右2種類）の伊勢擬革紙。

三重・伊勢

　日本の擬革紙は、伊勢神宮で有名な伊勢で生まれました。1684年に堀木忠次郎という人物が、油紙を改良して擬革紙をつくり始めたといわれています。それを煙草入れに加工して売り出したところ、これが大ヒット。

　当時は皮革がとても貴重なものだったこと、そして伊勢神宮へは殺生したものを持ちこまなかったことが、その背景にあります。時は流れ、段ボール箱一杯の擬革紙を目にした堀木さんの子孫が復元したいと思い立ち、『参宮ブランド「擬革紙」の会』を立ち上げます。

　しかし口伝だったため、詳しい製造法がわからない。そんな中、「紙の温度」にも相談にみえました。擬革紙に必要なのはもみ機とちりめん揉みの技術です。ちりめん揉みは滅びかけている技術ですが、幸い我が社にその技術を習得した女性がいて、復活の役に立つことができました。「かのこ絞り」と「さざなみ絞り」の2種類があり、名刺入れに仕立てたもの、朱印帳の表紙に使ったものもあります。

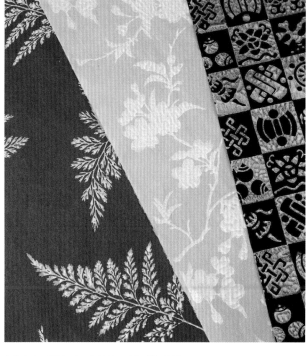

山崎商店の唐紙。左から忍（しのぶ）、桜、宝尽くし。

# 唐紙

平安貴族文化とともに発展しました
唐紙の決め手は版木の枚数

　唐紙は、もともとは中国から輸入した紙のことで、奈良時代に渡来したと言います。そして平安時代に入ると、貴族文化に浸透しました。いま唐紙と言えば主に襖に用いる、文様を木版摺りした紙を指します。

　京都の「山崎商店」は1976年創業と、唐紙の会社としては比較的新しい会社です。唐紙の決め手となるのが版木で、どれだけの枚数、つまり文様を持っているかが勝負どころ。山崎商店は伝統的な唐紙柄の復刻に加えて、新柄も積極的に製作しています。唐紙には、鳥の子紙を用いるのが一般的です。「紙の温度」でも、襖紙に使う大判は鳥の子紙ですが、小判（64cm×93cm）に関しては色の付いた薄手の民芸紙をこちらから渡して、それに摺ってもらっています。民芸紙の柔らかな雰囲気と唐紙の文様が相まって、インテリアのいいアクセントに活用できると思います。

125

# 竹紙、藤紙ほか

三宅賢三さんは、ふつうの紙漉きからは大きく逸脱しています。竹、藤、チガヤ、オニシバリ、ミョウガの茎。これらを原料に、紙をつくっているんです。三宅さんが紙漉きになろうと思ったのは30歳の時。私はこの頃に出会いました。それまで沖縄や北海道などで暮らし、結婚して子どももいた三宅さんは、京都の丹後半島に移住します。知りあった牧場のオーナーが「牛を見ながら紙を漉けばいい」と持ちかけてくれ、カウボーイ兼紙漉きの生活が始まりました。いまから40年ほど前のことです。「住み始めた当初、我が家には電気が来ていなかったので、ロウソクの明かりで手打ち叩解したこともありました」と話してくれたことがあります。

三宅さんが漉く紙の中でも特別な存在なのが、竹紙（ちくし）です。原料を買うにはお金が要る、でも竹なら牧場の周辺に山ほど生えている。紙漉きを教えてくれた師匠も竹の紙を漉いたと話していたことを思い出し、1987年、自ら伐って紙に漉

くことへの挑戦が始まりました。でも見たことのないものをどうやって漉けばいいのか、中国の書物などにあたりながら三宅さんは研究を重ねます。「竹で紙を漉く」と連絡をもらっていたので、期待して待っていたのですが、1年たっても2年たっても肝腎の紙は届きません。3年目、やっと100枚揃えてくれました。聞くと、最初は100枚漉いても98枚は破れていたというのです。雁皮のような薄い紙なので、板干ししてはがす時に破れてしまう。また、竹を紙にするには「熟成」という工程が必要です。熟成させてうまく腐らせないと、ざらついた、黒くて汚い紙になってしまうためです。

三宅さんは根気よく、竹に向き合いました。研究者肌でもある彼は、日付に始まり原料、煮熟剤、叩解、熟成期間、あらゆることを記録しています。頭が下がります。なので「紙の温度」では日づけ付きで置いています。宍倉さん（76ページ参照）に企画編集してもらい、三宅さんの竹紙ばかり28種類

原料である竹の熟成期間の違い、厚み違いの竹紙。

三宅さんが漉いたさまざまな
原料の紙。左からオニシバリ、
ミョウガ、ガマ、藤、チガヤ。

の見本帳も作成しました。竹紙は国宝を始め国の重要な掛け
軸などの修復に使われていて、三宅さんの腕が認められてい
ることは、私にとっても喜ばしいことです。

　冒頭に紹介した数々の植物は、すべて周辺に自生している
か、三宅さんが畑で育てたものです。紙漉き場が高天山とい
う山のふもとにあるため、彼は「高天山植物図鑑」と総称し
ています。

　藤やオニシバリはその昔は紙に漉いていたけれど
も、採取するのが大変だったり、紙になるまでの工程が手間
だったりで、いまは廃れてしまっている。そういう植物こそ、
三宅さんにとっては挑戦しがいがあるのでしょう。「紙漉き
がやりたくない紙は自分が漉く」。本当に、愛すべき変人で
す。

128

三宅さんの工房前に、漉いた和紙が天日干しされている。

三宅さんは漉いた紙の記録を綿密にとり、
次の紙づくりに活かしている。

さまざまな植物から紙を漉くため、
日々実験が繰り返される。

# 楮染紙 — 黒谷和紙

ハタノワタルさんは、いま一番脂ののっている紙漉きなのではないでしょうか。独特の色に染め上げた大判の和紙は既存の和紙にはない表情で、ホテルや飲食店、住宅の内装材として大変人気があります。ハタノさんは、黒谷和紙で紙漉きのキャリアをスタートしました。1997年の独立後も10年間は、自身の和紙制作をしながら黒谷和紙協同組合にも籍を置きました。現在は紙漉き工房兼和紙の実験的自宅で、和紙の可能性を見いだそうと精力的に活動しています。

ハタノさんの和紙はすべて楮です。それを色染めし、さらにオイル含浸などの加工を施して、建築内装材としての強度や防水撥水性を持たせています。和紙は摩耗に弱くて耐久性がクロスに劣るのではという心配を払拭させているのです。

彼は美大で油絵を専攻していました。その時に培った色使いや、数多くの建築現場に立ち会ったことで得たデザインのセンスが、大きな財産となっています。和紙としては、黒谷で

修行していますからもちろんいいものを漉きます。紙漉きは厳しい世界です。賃金も低いし、開放的か閉鎖的かと聞かれたら、後者でしょう。ハタノさんは、大好きな和紙にもっと光が当たって、たくさんの人が使うようになるためにはどうしたらいいかずっと考え、「紙を漉きながら、紙を使う側のプロになろう」と思ったといいます。「こういう目的で使うためには、どんな和紙がいいか」をイメージできる紙漉きということです。

自宅にうかがったことがあるのですが、床壁天井はもちろん、テーブルの天板も、ランチョンマットやお皿まで和紙なんです。本当に、自分で実験している。そして全国各地の建築家や工務店と連携して、和紙を供給する体制を整えています。小売店でハタノさんの紙そのものを置いているのは「紙の温度」を含め2軒だけで、建築家やインテリアデザイナーが指名で買いに来るほどです。

ハタノワタルさんがつくる楮で漉いた和紙を色染めした和紙。

# 紅型もみ紙 — 黒谷和紙

京都・黒谷

まるで呉服ですよね。沖縄の伝統的な染織技法である「紅型(びんがた)」で和紙を染めています。「紅」は色を、「型」は模様を指していて、型染めを施しています。金山ちづ子さんが京都・黒谷の和紙を使って、版を彫るところから色の指定、染めまですべてひとりでしています。

金山さんが紅型を用いるようになったきっかけは、黒谷和紙協同組合の前理事長から、「和紙に付加価値を付けた方が売れると思う。紅型染めはどうだろうか」と助言をもらったこと。それを受けて紅型染めの人間国宝の方や研究者に教えを請い、技術を身につけたそうです。もう半世紀以上前の話です。金山さんがすごいのは、そこからオリジナルのデザインをものすごく意欲的につくったことです。現在95歳の金山さんは数年前に引退され、いまは後継者たちが染めていますが、「紙の温度」には金山さんが現役時代の柄がまだ豊富に揃っていて、伝統的な柄からモダンなものまで約百種あります。

す。着物や帯の型染め教室に通っていたときの教材で布に染めたものを参考に和紙に転用したり(写真左)、金山さんの創作だったり(中)。大胆なものも繊細なものも、それを組み合わせたものもあって、本当に多彩です。また、こんにゃく糊を塗布して揉んだ強制紙で、糊のきかせ方がほどよく、柔らかみがあります。型染めの紙は、和紙人形の着物に欠かせないのですが、金山さんが手がけた柄は、人形にも実によく合います。紅型染めをしっかり勉強されたからでしょう。書物の装幀や、そのまま額に入れて飾るのもおすすめです。

とても思い入れのある紙です。「紙の温度」を開店する前に全国の産地を巡っていたときに出会い、こんなに素敵な紙があるならば、たとえ和紙が斜陽産業だとしてもやろうじゃないかと心に決めました。出会わなかったら、お店はなかったかも知れません。黒谷から帰る車中、同行した社員と興奮の時間を過ごしたことを、いまでも鮮明に思い出します。

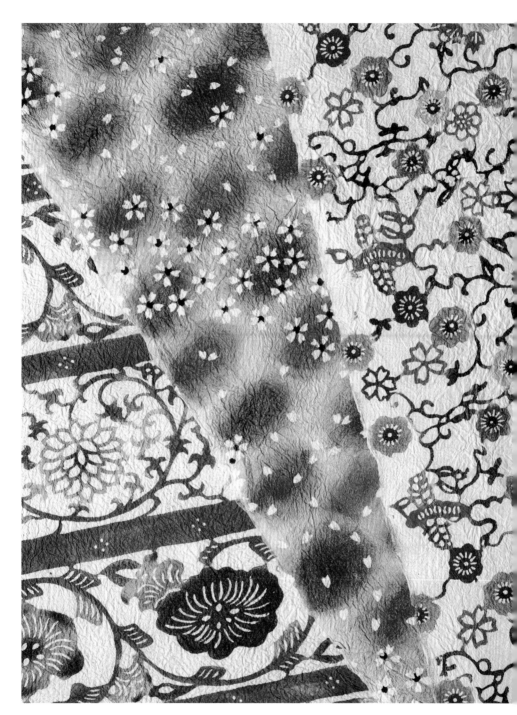

金山ちづ子さんが染めた紅型もみ紙。
右は沖縄の古典柄の型に金山さんの色差しをしたもの。

# 流水すかし紙、強制紙 ── 黒谷和紙

黒谷和紙は、京都府綾部市黒谷町・八代町およびその周辺地域でつくられた紙を指します。13世紀に平家の落ち武者が都から黒谷に逃げてきて隠れ里をつくり、生活の糧として紙を漉き始めたことが始まりと伝えられています。その昔は雁皮も三椏も漉いていましたが、いまは楮のみに絞っています。以前は黒谷川に沿って多くの紙漉きがいて個人の工房もあったのですが、現在は黒谷和紙協同組合として、伝統的な手漉きの手法を守っています。

黒谷和紙の特徴は、やはり都だった京都に近いこと。値札、渋紙（型紙のこと）、着物を着替えるときに下に敷いたり保管のときにくるんでおくたとう紙など、京呉服に関連した紙をつくってきました。かつては京都向けの紙漉き場であり、加工所だったと言えます。品の良さとでも言いましょうか、和の伝統が息づく京都の雰囲気がそのまま黒谷に持ちこまれ、ブランドとして確立しています。いまでも封筒や便箋、

木版手摺りの祝儀袋、耳付き和紙の葉書といったものには「黒谷」と明記され、それを求める人も多くいます。

強制紙はあずき、赤、緑などがあり、色の出し方、ムラのなさなどやはりうまいです。色の良さに加えて強度の面から見ても、強制紙の色紙としては黒谷が抜きん出ていると思います。透かし技法も得意で、涼やかな水色に先染めで漉いた流水すかし紙など、風情があって、まさに透かして見たくなります。どちらもこの土地だけでつくっている技法の和紙というわけではないのに、「黒谷らしさ」を感じさせる、それがこの土地の強みです。

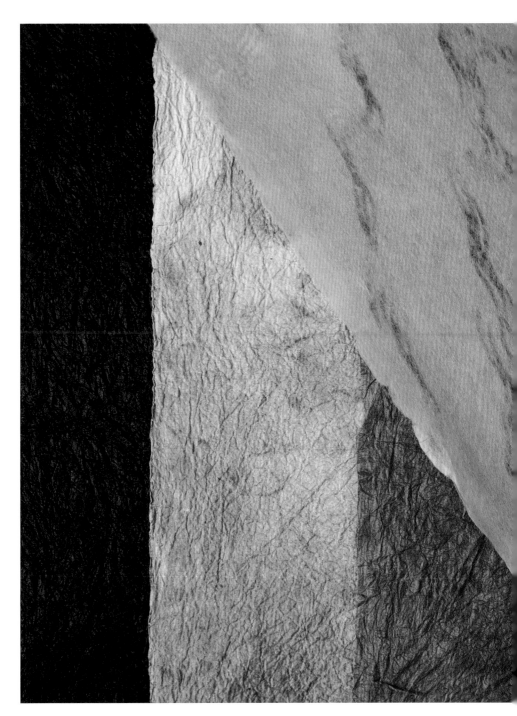

黒谷和紙の染め強制紙と、流水すかし紙（右上）。

杉原紙（左）と米粉入り和紙（右）。

○
兵庫・多可町

# 杉原紙

一度は途絶えてしまった和紙づくりを
町民総出で復活させた希有な例

　関西で和紙と言えば杉原紙のことを指し、中世の武士社会で最も多く流通したと言われています。ですが明治維新以降、収益性の高い別の産業に乗り換えたり、地元で採れる楮の量が減少したことなどが原因で、1925年に一度途絶えました。1965年、地元の有志が復活させようと「杉原紙研究会」が発足、後に町立の「杉原紙研究所」が設立されます。1994年には町民全世帯参加による「1戸1株栽培運動」も始まり、ほぼ地元産の楮で漉けるまでになりました。町ぐるみで和紙を復活させた、全国でも珍しい例です。

　杉原紙研究所では楮100％の紙と、米粉入りの楮紙を漉いています。江戸時代、お米は紙よりも安価なため、増量剤として使用されていたそうで、重量で取引される紙ならではの歴史ですね。現代の紙としては、米粉が入ることで目が細かくなり、版木を押したときに発色が良く、墨のにじみも遅いというのが利点です。ただしお米ですから虫がつきやすい点は考慮しないといけません。

136

箔打紙と、使用後の箔打紙を小判に断裁したあぶらとり紙。

# 箔打紙 —— 名塩和紙

六甲山系で採れる雁皮に土を入れることで
金箔づくりに欠かせない強い紙が生まれます

兵庫・名塩

名塩和紙は、六甲山系で質の良い雁皮が生育していることから、原料が楮ではなく雁皮です。馬場和比古さんが漉くのは、金箔づくりで打ち延ばすときに使う紙です。金箔は、金と箔打紙を交互に重ね、専用の器具で叩いて極薄にします。繊維が細密で平滑な紙になる雁皮に土を入れることで、強度と耐久性が増し、叩く時に強い力がかかっても破けない紙になります。馬場さんが漉く紙の大半は金箔づくりが盛んな石川県金沢市で使われています。いい金箔を今後もつくれるようにと、馬場さんの紙を20年分確保している金箔屋さんもあると聞いたことがあります。箔打紙の質が金箔の質を決めると言われる中で、馬場さんの紙が評価されている証ですね。「紙の温度」には、箔を打ったあとだけでなく、打つ前の紙も置いています。女性ならよくご存じのあぶらとり紙は、そもそもは金箔屋さんが使い終えた箔打紙が使われていました。いまは量産品に取って代わり、写真のあぶらとり紙はもう販売していない貴重なものです。

137

雁皮のみでつくられた間似合紙（左）と、
古紙も使った再生間似合紙（右3種類）。

兵庫・名塩

# 間似合紙 ― 名塩和紙

いろんな用途に「間に合うから」ついた名前
土入の不思議な質感に触れてみてください

名塩には137ページの馬場さん以外にも
う一軒、「谷徳製紙所」という紙漉き工房が
あります。先代の谷野武信さんが人間国宝に
認定され、現在は息子の雅信さんが継ぎ「間
似合紙」を漉いています。「間似合紙」も土
（泥）入の雁皮紙です。そして日本では珍し
い溜め漉きで漉いています。土が入ることで
少しマットな、不思議な質感です。燃えにく
く変色せず、虫がつかない上にシミも出ない
という特徴が好まれ、重要文化財の壁紙や襖
紙に好んで使われています。またきめ細かく
滑らか、墨ののりも絵の具の発色もよいこと
から、書画やカリグラフィーにも使われてい
ます。「間似合紙」とはなんともユニークな
名称ですが、襖に屏風に衝立にとなんにでも
間に合うということからとも、半間（三尺）
の間尺に合う紙からとも言われています。雁
皮に土を入れたもの以外に、和紙古紙に土を
入れたものもあります。入れる土の色によっ
て紙の色が異なります。

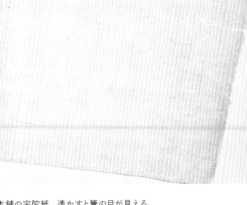

福西和紙本舗の宇陀紙。透かすと簀の目が見える。

# 宇陀紙 — 吉野紙

ふだん目にすることのない、表具の一番裏の紙
掛け軸を丸めるときの、縁の下の力持ちです

古い歴史を持つ奈良県吉野では、修復に使われる紙が漉かれています。書画の修復に用いる和紙の制作に携わり、現在は六代目の福西正行さんが漉いています。

宇陀紙は、表具の裏打ち用の和紙です。吉野の近隣である宇陀町の商人が売り歩いたため、この名が付きました。表装は通常3層から成ります。絵や書に直に裏打ちする薄美濃、クッション材の役割を果たす美栖、最後が宇陀です。宇陀紙は楮に白土を入れて漉くことで、強度と柔軟性が生まれます。そして宇陀紙が最後にあることで、掛け軸を丸める時にも伸ばす時にもスムーズになるそうです。保存性にも優れているという特性も有利にはたらきます。ちなみに修復の肝となるのは、紙と糊です。いい表具屋は、甕の中に糊を入れて長期間熟成させています。粘着力はほとんどなく、裏打ちのたびに刷毛で何千回と叩いて紙の繊維をほぐして接着させます。だから裏から水をかけたら紙同士がすぐにはがれて、修復にあたれるのです。

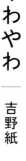

やわやわ ── 吉野紙

室町時代の最高級ティッシュペーパー
薄くて柔らかくて丈夫な紙です

漆を漉す際にこの「やわやわ」に入れて絞ることから
「漆こし」とも呼ばれる。

奈良・吉野

この白雪という紙は別名やわやわとも呼ばれ、昆布尊男さんが漉いています。昆布という名前なのに吉野の山にいるのがなんとも面白く、初めてお会いしたときに「海側のご出身でしょう？」と聞いてしまいました。やわやわは室町時代に起源を持つ、最高級ティッシュペーパーです。薄くて柔らかくて、室町時代の貴族の優雅さに感じ入ります。極薄なのに粘り強さを持ち合わせ、その上、目が細かいことから、漆こし紙や油こし紙として使われてきました。和紙は薄くても丈夫なものなんです。不織布の登場以来、すっかりお役を奪われてしまいましたが、漆芸作家の方が「本物の漆こし紙がここに売っているんですね」と感激したように言いながら買っていったことがあります。もったいなくて使えないかもとおっしゃっていましたが、ぜひ古から受け継がれてきたやわやわの使い心地を試していただきたいものです。

中坊さんの高野紙（左）と飯野さんの高野紙（右）。

高野紙

最後の紙漉きから役所勤めの女性へのバトン渡し
ユニークな製法が生む素朴な楮紙

和歌山・高野町

　87ページで紹介した埼玉の小川和紙は、和歌山の高野山麓の細川村で漉かれていた丈夫な和紙の漉き方が伝わったそうです。そのオリジナルである高野紙は、最後の漉き手だった中坊佳代子さんが15年ほど前に引退したことで、一度途絶えかけました。切れかけた細い糸をつないだのは高野町の職員で、町史編纂室を経て教育委員会で働いている飯野尚子さんです。働きながら中坊さんを訪れてさまざまに質問し、漉き方を修得しました。高野紙は小判しか漉かない特殊性があり、13枚の萱簀を用意してどんどん漉いて濡れたまま立てかけておく、板干しする時も刷毛を使わずに周囲を手でなでるなど、素朴なまま進化を止めました。そういう百姓的な紙だからこそ、飯野さんが働きながら挑戦できたという側面があると思います。　小判なのは傘紙などとして用いられていたからですが、実は高野山には、文書に使われた高野紙がのこっています。それを再現していきたいというのが、飯野さんの思いです。

漉いている人のエネルギーが紙に凝縮されている

見る人を魅了する、いろいろな青

# いろいろな青の紙

明松政二（かがり）さんはとても元気で、とても破天荒な人です。もとはお役人で、31歳で辞めると家業を手伝いながら全国のものづくりの産地を訪ねる中で、和紙に出会いました。茨城県西ノ内で修行後、生まれ故郷である大阪の泉佐野に工房を構えます。

井戸水がある恵まれた環境だったのが関西空港建設などの影響からか、一時期水質が悪化してしまい、新たな場所を探します。そしてたどり着いたのが鈴鹿山系の青山高原でした。私も訪れていますが、行くと水汲みなどを手伝わされます。ものすごく好奇心が旺盛で、ネパールでは山の中で寝泊まりしたり、紙のためには労力を厭わない。その分、奥さんは大変だったと思います。その土地で採れる木の樹皮で紙を漉こうと思い立ち、全国行脚したことも。北海道でも沖縄でも漉いたそうです。北海道は稚内から車で2時間ほどの音威子府、沖縄は本島の東風平町（こちんだ）（現八重瀬町）と阿嘉島（あか）で漉いたのですが、沖縄で使った水は天水（雨水）、天水がない力強さのある紙です。

ければ水道水、それもなければ海水で、しかも海中で漉いたというから驚きを超えて異常（！）です。明松さんも、私が敬愛する変人のひとりです。さらには「樹皮は植物そのもの」という考えのもと、これまでにミモザ、ザクロ、キンモクセイ、梅、楓、椿、キョウチクトウ、イチジクといったさまざまな木の樹皮から紙を漉いています。

個展を開催し、そこで販売することが大半で、お店で扱っているのはうちぐらい。近年の青い紙ばかりの展覧会がとても良くて、「紙の温度」でもいろんな青い紙を置いています。ラピスラズリの青を見てからこの色が気になり、はまりこんだのだとか。青の紙の時には楮や雁皮を漉いて、国内外の染料で表情豊かに染め上げています。明松さんの紙にはエネルギーを感じますし、その風合いも魅力です。特に決まった用途があるわけではなく、紙の方が人を選ぶ。心揺さぶられる、

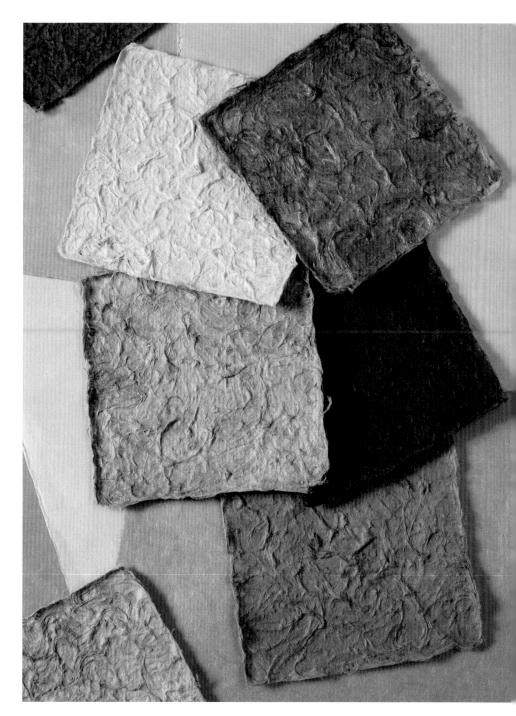

スムースなものから原料繊維が主張するものまで表面もいろいろな青の紙。

静電気が起きにくくて湿気も入りにくい
金箔の間に挟むのに適した紙

# 津山三椏箔合紙 ― 横野和紙

手前側に折り返した二重部分が。
写真は二層紙のため二重部分がふたつ見える。

岡山・津山

　津山で漉かれる和紙は、土地の名前から横野和紙と呼ばれます。いまは上田手漉和紙工場が1軒残るのみで、七代目の上田康正さんが津山三椏箔合紙を漉いています。岡山は三椏の産地で、箔合紙はできあがった金箔の間に挟む紙です。三椏を煮熟するときにソーダ灰ではなく消石灰を用いるのが特色で、そうすることで静電気が起きにくくなり、箔を挟むのに適しているというのが、紙の専門家である宍倉さん（76ページ参照）の見立てです。湿気も入りにくく箔がくっつくことがなく、金箔を扱う人たちには欠かせない紙です。

　金箔には一層ですが、二層紙もあります。楮と比べてそこまで吸い込まないため筆すべりや墨の発色が良くなり、かな書きにも向いています。三椏に文字を書くとうまく見えます。書道系の方はそのことを知っていますから、この紙を好んで買います。端を二重に折っているのは、脱水後に紙床からはがしやすくするためです。薄紙に多く見られ、手漉き和紙の証と言えます。

144

十川泉貨紙。

## 十川泉貨紙

2枚を貼り合わせて1枚にする不思議な紙
真面目に取り組む若手の紙漉きがいます

高知・四万十町

紙に詳しい人ならば、仙花紙やせんか紙をご存じでしょう。前者は厚手の粗い和紙、後者は週刊漫画誌によく使われるザラザラした紙で、どちらも上質ではありません。泉貨紙は発音は同じですが別物で、2枚を貼り合わせて1枚にするという特殊な製法の和紙です。

最初に漉いた人の号から名付けられました。漉いたら瞬時に貼り合わせるため、少しだけ厚い1枚にしか見えない、不思議な紙です。とても丈夫で、元々は裏張りに使われていました。全国でも漉いているのは2、3軒と少ないのですが、高知の四万十町で期待の若手が漉いています。平野直人さんはまだ30代、お母さんはじめ周囲から泉貨紙の技術を受け継ぎました。高校卒業後すぐに紙漉きの道へと進んだ平野さんを両親も応援、大工のお父さんが工房を建ててくれたそうです。楮も自ら栽培し、夏から秋の間の紙漉きに向けて、下準備にも余念がありません。ひたむきに和紙づくりに取り組んでいる若手がいることに、嬉しくなります。

145

# 土佐七色紙 ── 土佐和紙

雁皮紙を草木染めした、光沢のある美しい紙
なくなってしまうその前に手に取ってほしい

土佐和紙は、美濃和紙、越前和紙と並び三大和紙と称されます。『土佐日記』を綴った平安時代の歌人・紀貫之が土佐の国司に着任した際、製紙業を奨励したと言われていますから、その歴史は古いもの。「鹿敷製紙」は現在四代目の濵田博正さんが切り盛りしています。鹿敷製紙の特徴は、非常に上質の紙を機械抄きでつくっていることです。「手漉き紙を機械で抄く」という考えに基づき、原料処理は手漉きとまったく同じに行っています。博正さんの祖父である繁信さんがすごく腕のいい人で、いい職人さんも揃っていました。その和紙が基準になっているからでしょう、機械抄きでも見劣りすることがまったくなく、修復の世界でも「鹿敷さんなら（機械抄きでも）いい」と認められています。機械抄きというと量を追いがちですが、鹿敷製紙は違って、機械をものすごくゆっくり動かすんです。手漉きと同じくらいの時間をかけているのではないでしょうか。雁皮紙の薄手が特に得意で、

薄い紙を均一に仕上げるには機械が向いているとも言えます。江戸時代に幕府指定の献上品として藩の保護を受けたことで、土佐の特産品として広く知られるようになりました。ヤマモモやクチナシ、藍、スオウなどを使って雁皮紙を草木染めしています。手漉きと機械抄きがあるのですが、鹿敷製紙でももうつくっておらず、蔵にある在庫をわけてもらっています。薄くて光沢があり、とても美しい紙です。桜、うす紫、水色、渋めの水色が、いまならまだあります。こちらもやはり銅版画家にファンが多く、たくさんの枚数を一度に買う方もいらっしゃるほどです。

修復の方たちだけでなく、「雁皮刷り」をする銅版画家にファンが多いです。雁皮刷りは銅版と用紙の間に雁皮を挟んで刷ります。刷り上がりに光沢が出て、細かな絵柄も再現できる技法です。

なんとも淡くきれいな色の雁皮紙は、「土佐七色紙」と言います。

先代がつくった手漉きは耳付き、
耳がないのは四代目が機械抄きした、艶のある色雁皮紙。

極薄だけれども丈夫で修復に人気の楮紙を原紙に
細かな雲母が入って上品なきらめきを放ちます

# 雲母入り典具帖紙 ── 土佐和紙

典具帖紙とは、楮を漉いた極薄の紙のことです。「カゲロウの羽」とも呼ばれるように薄くて強く、最も薄いものは0・02ミリ程度で、手をかざすとそのまま手が見えるほど。発祥は美濃で、室町時代には漉かれていたのが、土佐にも伝わりました。典具帖紙の用途としてよく知られるのが、タイプライター用紙です。なぜ和紙なのにタイプライター？ それは1881年に開催された第二回内国勧業博覧会に出品したことに端を発します。インキののりが良く、タイプしても破れない強さが認められ、評価を得たと言われています。

日高村にある「ひだか和紙」は、典具帖紙に熱心な工房で、1969年には機械も導入しました。その薄さから、国内外でさまざまな修復に使われています。書物に表打ちしても問題ありませんし、皮革装幀本にも向きます。海外では油絵の修復に人気です。ひび割れた油絵の具に網のようにかぶせてニスを塗布すると、薄い典具帖紙は見えなくなってしま

う。実に重宝です。そしてひだか和紙は2021年、鳥取で廃業された和紙工房のみなさんを、機械ごと呼び寄せました。ふたつの工房が組み合わさったことで、色の幅も増えました。さらには色のデータベース化にも取り組んでいます。これはいろんな産地が挑戦しては道半ばであきらめてしまっていることなので、ぜひ完遂してほしいものです。

バラエティに富んだ色典具の新作が雲母入りです。薄い典具帖紙に細かな雲母がちりばめられています。藍の典具帖紙だと七夕の夜空のようで、黒のそれだと漆黒の闇に光る星のようです。大きな雲母を入れて漉くところもあるけれども、典具帖紙にはこの細かさがよく合っています。色典具は押し花やちぎり絵の背景に使われることが多いのですが、ちょっと贅沢なラッピングや和紙細工に用いると、このきらめきが活きるのではないかと思います。

高知・日高村

ムラ染めやグラデーションに染められキラキラした雲母が入った、
ひだか和紙の雲母入り典具帖紙。

書道家に人気の紙の漉き手は四代目
楮と三椏、それぞれの特徴を活かしています

# 清帳箋、清光箋、みづほ染紙 ── 土佐和紙

高知の仁淀川町・寺町地区にはかつて70軒ほどが紙漉きをしていましたが、いまは尾崎製紙所1軒となりました。四代目の片岡あかりさんは三姉妹の次女で、小学生の頃から紙づくりの手伝いをしていたそうです。現在は、公務員だったご主人の久直さんも共に紙づくりをしています。

尾崎製紙所を訪れたとき、そのロケーションに本当にびっくりしました。工房が、文字通り崖の上に建っているのです。工房周辺は急勾配で紙を干す場所がないため、ケーブルで吊してその場所まで運んでいるのにまたびっくり。ガードレールのない山道を運転しなければならず、社員とヒヤヒヤしながら降りたことを覚えています。

片岡さんが漉く紙は高級画仙紙として、全国の書道家に人気があります。みなさん、練習ではなく本番用に求めます。楮で漉いた「清帳箋」は、墨のくい込みが良く、太い筆で墨をたっぷりと使う漢字に向きます。65×182センチの大判、晒しもあります。

75×140センチの全紙と、その半切り、四つ巾があります。昔は38×102センチで、とある書道家から依頼されて75×102センチ（四つ巾）を漉くことに。二代目が道具を新調して応えました。これが評判を呼んだと言います。同じ書道家からの、三椏で漉いてほしいという依頼から生まれたのが「清光箋」。こちらは墨の発色が良く、細かな書きをしたためる短歌や和歌におすすめです。「みづほ染紙」は楮紙にドーサ引きを施してからあと染めしていて、いい色を出しています。緑、藍、紫、茶の4色で、染めていない未

電線のように見えるのが、紙を干し場まで
運ぶためのケーブル。

高知・仁淀川町

写真左からみづほ染紙（4色）、清帳箋、清光箋。

# 高知麻紙 ── 土佐和紙

麻の繊維は最長25cmもの長さ
キャンバスの代用になる厚みがあります

表は比較的スムース、裏は凹凸がある高知麻紙。

高知・いの町

　原料に麻が使われているものを麻紙と言います。尾﨑製紙所の麻紙の原料は麻と楮。手漉きの動作を機械に置き換えるために試行錯誤しながら、改良を重ねました。麻の繊維はほかの植物と比べて長いという特徴があります。たとえば楮の繊維が1センチほどなのに対して、麻はなんと2センチから25センチもあるんです。長すぎると繊維同士が絡まないため、切ることもあるほどです。また繊維がうねっているため重なり合った時に隙間ができるため、そこを埋めるべく楮を使います。

　麻紙はキャンバスの代用として生まれました。できあがった紙はゴワゴワしていてやわらかな凸凹があります。ドーサ引きしていることで「ゴワッと感」がさらに増します。それが絵の具との相性の良さにつながっています。また厚みもあり、特厚口、厚口なら裏打ちがいりません。裏打ちはけっこうな手間なので、それが不要というのも人気の理由です。

通称「茶チリ紙」とも呼ばれる裏張り紙（古代色）。

## 裏張り紙（古代色） ── 土佐和紙

チリは入っていないのに「茶チリ」と呼ばれます
表具の裏張りに適しています

「内外典具帖紙」は社名があらわす通り、高知で古くから典具帖紙を漉いています（現在は機械抄き）。ご紹介する「裏張り紙（古代色）」は、主に表具の裏張りに使う紙です。

チリは入っていないのに、なぜか「茶チリ」という別名があります。古い掛け軸などの裏に貼るために、茶色くしてあります。その古びた色がいいと言われることがよくあります。別名を不思議に思いお聞きしたところ、手漉き時代はチリばかりで漉いた紙もあったそうで、それを「チリ」と言っていたとのこと。紙は違えど、その呼称がのこっていたようです。チリと呼んでいたものは、原料の堅い茎も入っていて丈夫、黄土色がかった茶色い紙で、やはり裏張りや唐紙の修復が主な用途だったようです。 楮40％に対してパルプを60％混ぜてあるので、求めやすい値段です。私は自宅の壁に和紙を貼る際に下貼りしました。クッション材や肉付けにもなるので、屏風や障子の腰張りの下貼りにも使われます。主役を支える脇役的な、息の長い紙です。

153

# 夢幻染め和紙 ── 土佐和紙

田村晴彦さんの「夢幻染（むげん）」は、まるで1枚の絵を見ているような気持ちになる紙です。もともと紙漉きの家に生まれて、ご自身も三代目として紙を漉いていました。私たちが通い始めの頃は、まだ紙漉き職人が漉いていました。刷毛を用いた縞模様などの引き染めは、お父さんの代からしていました。田村さんは若いときから染色に興味があり、20代の頃から和紙に刷毛で着色した作品づくりをしていたそうです。そして原料づくり一筋に徹していたお父さんが94歳で他界し、染色の注文が増えたことで還暦を機に染め一本に絞りました。夢幻染めは田村さんが独自に編み出した技法です。夢や幻のように、型にとらわれない自由さを表現しているとから「夢幻」という名が付きました。にじみ止めを紙に落とすことで、その部分には染料が付きません。それが水しぶきのようだったりして、染まっている部分を引き立てます。ちぎり絵やその台紙などに使われることも多いようです。

ムラ染めや板染めといった技法としての名称でなく、夢幻染めという独自の染めの名前が認知されている紙はほかにはなかなかありません。田村さんは本当は、作品づくりに没頭したいのだと思います。「紙の温度」に置く紙も、最初はご本人の感性のおもむくままに染めてもらっていました。いまはロクタ紙を渡して夢幻染めをしてもらったり、色もこちらからリクエストしたりしています。内装に和紙やロクタ紙などを使うときは無地のものが多いのですが、夢幻染めが好きだという建築家やインテリアデザイナーも多く、壁だけでなくテーブルに貼った方もいます。田村さんは夢幻染め以外にも、刷毛を使った変わり型染めなども手がけます。ずっと若々しい感性を保っていて、創作意欲は湧くばかり。作品としてつくるものはものすごく大きくて、そのエネルギーに感服せずにはいられません。

○
高知・いの町

154

写真左から夢幻染め（3種類）と変わり型染め。

柿渋を入れて漉いているこの世で唯一の紙
上品な桜色が変化する過程も楽しんで

# 柿渋漉込和紙、楮雲龍紙（荒筋）——因州和紙

産地としての鳥取のイメージは、以前はあまりいいもので
はありませんでした。大阪商人の下請けという役割を担って
いたため、商人から「木材パルプを入れて漉け」と言われた
ら、意に添わなくても従わないといけない。しかもそれが楮
100％と表示される。悔しい思いをしていたことでしょう。
私も鳥取を訪れて、木材パルプを入れているなら嘘はつかな
いようにと強く言いましたし、それで楮だけで漉くようにな
ったところもあります。私の辛口も、鳥取では少しは役に立
ったと思います。

柿渋紙というと、ふつうは漉いた紙に柿渋を塗ったものを
指します。紙を漉く際に使うネリ材（繊維を絡みやすくさせ
るもので、主にトロロアオイが使われます）と柿渋の相性が
悪いためで、柿渋を入れて漉くことはできないというのが専
門家の意見です。ところが池原製紙の池原和樹さんは、柿渋
を入れて漉くんです。県の公的機関の研究員のアドバイスを

もらい実現に至ったそうです。柿渋は塗るとどうしても刷毛
目が出ますが、この紙は均質ですし、なにより薄い上品な桜
色がいい。池原さんは塗るという工程を加えずに、あくまで
も漉く工程の中に柿渋を使いたかったのではないでしょうか。
私はこの紙が大好きで、自宅の座敷の壁に貼りました。時間
がたつと色は徐々に濃くなりますが、やさしく上品な茶色く
らいで留まります。原料はタイ楮100％で手漉きです。

もうひとつ、池原さんはお値打ちの和紙をつくっています。
タイ楮を用いた雲龍紙で、30×49センチの小判が100円台
です。繊維が織りなす雲の様子や荒筋が、いい表情をつくっ
ていて、「和紙っぽいもの」がほしいならこれで充分だった
りします。マニラ麻90％日本楮10％のものもあってこちらも
100円台。マニラ麻が入ると丈夫な紙になります。

写真上が池原製紙の楮雲龍紙（荒筋）、下が柿渋漉込和紙。

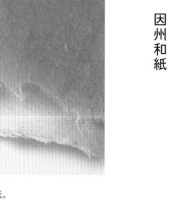

日本で漉いたロクタ100％の第一号
ネパールのロクタ紙との違いも楽しめます

# ロクタ手漉き紙 ── 因州和紙

雁皮に似て、若干の光沢がでた日本で漉いたロクタ紙。

鳥取・青谷

ロクタはネパールに生育する木で、12ページで紹介しました。そのロクタを日本で漉いたらどういう紙になるのか、ずっと興味津々だったんです。でもロクタを原料のまま輸入するのは最近まで難しく、なかなか叶わなかったのですが、ルートが見つかったことで実現しました。鳥取の長谷川憲人さんとは付き合いが長く、彼はふだんは楮を漉いたり、板締めの染め紙もつくっています。仲よしのよしみで打診したら快く引き受けてくれて、現地の素朴なロクタとはまた違う、きれいで洗練された紙ができました。2018年のことで、日本の紙漉きがロクタ100％で漉いた第一号だと思います。楮というよりは同じジンチョウゲ科の雁皮と似て、光沢のあるチャリチャリした紙です。ただ、いつも漉く楮と比べて、細い枝が入っていたり、チリ取りが大変だったかも知れません。なので漉いてもらった分はすべて「紙の温度」が引き受けました。

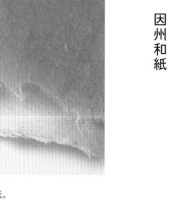

158

楮の甘皮をのこして漉くのがこの産地の特徴

独自のブランド「稀」を4軒で築いています

## 稀——石州和紙
まれ

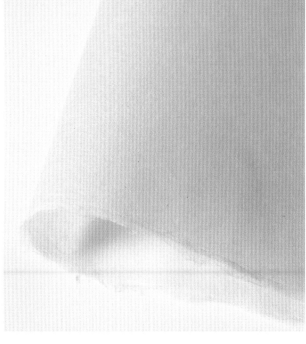

久保田さんの「稀」。
四ツ判（半紙の4倍のサイズ）のものが「紙の温度」にある。

島根・浜田

　島根県浜田市（もとは三隅町）には現在4軒の工房があり、「稀」という共通のブランドを持っています。美濃和紙の本美濃のようなもので、それぞれの工房で最上の楮紙に「稀」と名付けているのです。石州和紙の特徴に、原料の扱いがあります。通常、楮を蒸してから皮をはぐ際に、黒皮とその次の甘皮（青皮とも言います）を取り除いて白皮だけの状態にします。ですがここでは甘皮をのこすんです。「なぜ皮」という製法です。甘皮は緑色をしているので、できあがった和紙もほかの産地のものと比べてほんの少し緑がかっています。

　4軒とも畑を持っていますので、地楮で漉いています。石州和紙久保田の久保田彰さんは、楮だけでなく三椏も雁皮も漉きます。「紙の温度」にある久保田さんの「稀」は四ツ判です。「稀」を求めるのは書道家の方が圧倒的に多く、墨のりの良さが好まれています。表具用紙にも石州半紙が必要不可欠なものとなっています。

159

# 柿渋染め和紙 — 石州和紙

ムラなく仕上げるのが難しい柿渋を
3回塗って均一にする腕の良さ

揉み紙の柿渋染め和紙（上）とプレーンな柿渋染め和紙（下）。

島根・浜田

　西田和紙工房は、七代目の西田誠吉さんが、息子の勝さんとともに切り盛りしています。楮が中心ですが、三椏と雁皮も手漉きしています。おそらく修復用でしょう、アメリカのボストン美術館に毎年一定量の楮紙をおさめています。また、この地方の伝統芸能のひとつである「石見神楽舞」に登場する「蛇胴」にも、西田さんの和紙が使われています。迫力ある鱗が彩色された大蛇は実に見応えのあるものです。柿渋染め和紙は、漉きも染めも西田さんが行っています。柿渋は均一に塗るのがなかなか難しく、ムラになってしまうのですが、西田さんは手慣れたものでとてもきれいです。薄口の楮紙に3回塗り重ねています。時間の経過とともに色は濃くなります。柿渋には防虫・防水効果があり、柿渋染めの和紙は番傘や合羽などに使われてきた歴史があります。

## 料紙 ── 石州和紙

書を引き立てる勘所にすぐれている
漉きと料紙加工を高いレベルで両立させています

部分的に落水模様が入ったもの（上）、金箔漉き込み（右）、
版木で刷った料紙（下）。

島根・浜田

西田製紙所の西田裕さんは料紙づくりに長けています。紙漉き場とはべつに料紙加工用のスペースを設けて、さまざまな料紙をつくっています。どれも面白い紙です。楮紙に金箔を漉き込んだものや、一部を落水で仕上げたものなど、どういう料紙にすると書が引き立つかがよくわかっている。書の見どころをつかんでいるんですね。版木をたくさん持っているのも強みで、複雑な模様をつくれます。

漉きと料紙加工を高いレベルで両立しているのですから立派です。書き味に対しても、楮、雁皮、三椏の特性を把握した上で漉いています。求められる書き味に合わせて、原料の配合を変えられる。たとえば雁皮だけだと書をしたためたあとに乾燥すると引っ張られてしまうところを、三椏を入れることで抑えています。こちらから極薄のロクタを渡して、西田さんが持っている版木で摺ってもらったものもあります。版木のすり減っている箇所は模様がかすれているのも、いい味になっています。

161

和紙とひたむきに向き合った安部榮四郎さん
その技術と精神はいまなお受け継がれています

# 出雲民藝紙 ── 出雲和紙

島根県松江に、近代における和紙のパイオニアとも言うべき人物がいました。安部榮四郎さん（1902年〜1984年）です。紙漉きの家に生まれた安部さんは、島根県工業試験場紙業部で多種多様な紙漉きの方法を試みて技を向上させ、島根を巡回して職人の技術指導にあたりました。安部さんにとって人生を変える出会いが、1931年に訪れます。民藝運動の提唱者である柳宗悦氏が松江を訪れ、雁皮紙を見て「これこそ日本の紙だ」と誉めたたえたのです。これを機に安部さんは民藝運動に参加し、「出雲民藝紙」が生まれます。楮、三椏、雁皮、それぞれの持ち味を最大限に発揮させることに、安部さんは心を砕きました。そして1960年からは、正倉院宝物殿で保管されてきた紙について、研究家とともに調査研究を開始。3年の月日をかけて、和紙の原点とも言える正倉院宝物紙を復元させます。1968年には和紙に携わる人で初の人間国宝に認定されます。国内外で数多く

の展覧会を開催、和紙の魅力を広く伝えたのも安部さんです。1983年には「安部榮四郎記念館」が開館し、和紙に関する資料や民芸品を公開しています。ものすごく緻密に記録していて、どれほど熱心に和紙に向き合っていたかが伝わってきます。沖縄の芭蕉紙（171ページ）を復活させたのも、安部さんの大きな功績です。

安部さんの工房「出雲民藝紙工房」は、孫の信一郎さんと紀正さんが継いでいます。ふたりで榮四郎さんの技術と精神を守っています。出雲民藝紙は染め紙、八雲雲紙、水玉紙など、バラエティに富んでいます。三椏紙を染めた染め紙はどれもきれいな色ですが、「紙の温度」には紺色があります。藍染と見間違うほどの発色の良さがとてもいい。八雲雲紙は創作和紙の代表と言えるもので、どんな色をどんな配置にするかでバリエーションが生まれます。ふわふわと雲のように漂う色は見飽きることがありません。

写真左から八雲雲紙、水玉紙 (2色)。

# 泥染め和紙、板目和紙 — 斐伊川和紙

泥がこんなにカラフルなんて
板目がこんなにくっきりつくなんて

井谷伸次さんの「斐伊川和紙」は、奥出雲に流れる斐伊川の近くにある工房です。泥染め和紙は文字通り泥で染めた雁皮紙で、赤土、白土、鬼板、たたら鉄の4種類。土は茶色と思い込んでいたら、こんなに色が違うなんてと驚かれるはずです。

赤土は酸化鉄の泥を、白土は炭酸カルシウムと石灰を使っています。白土は漆喰の雰囲気とよく似ています。鬼板とは聞き慣れないかも知れませんが、陶芸で使われる釉薬の一種で、褐鉄鉱（鉄化合物を含む鉱物）のこと。そしてたたら鉄には、細かな粒子状の鉄が使われています。日本刀の材料である玉鋼の生産には、「たたら製鉄」という技法が用いられます。この地域でもたたら製鉄が行われていた時代があり、斐伊川では砂鉄の収集が行われていました。住民も自ら製鉄して刀剣や包丁をつくって売っていたという歴史があります。その際、刀にならない質の鉄は河原に捨てられ、井谷さんは

その鉄分が混ざった泥で漉いていたこともあるそうです。どれも分厚く漉いていて、壁紙に好んで使われます。厚いので下貼りがいらないという利点もあります。

いまは「紙の温度」に置いていないのですが、井谷さんが漉く紙に雁皮を板干ししたものがありました。板目がくっきりと紙に写し取られています。グリーンやピンクのパステルカラーと紙の板目のコントラストがユニークで、封筒や便箋にすると、その個性が際立ちます。これだけ板目がくっきりと和紙につくということは、やはり長期間使われて、痩せた板になったのですね。おそらく江戸時代から使われていたのだと思います。

泥染め和紙。写真左から、鬼板、白土、赤土、たたら鉄。

# 剥がれる和紙 ── 広瀬和紙

剥ぐことができるから色の濃淡が生まれる
ちぎり絵以外にも使える特徴のはず

二層で漉いているため、
破ると独特の二層の切り口になり切り絵に重宝される。

島根・安来

　島根県安来市広瀬町にある「広瀬和紙製作所」の長島勲さんが漉く小型の手漉き着色紙には、面白い特徴があります。三椏で漉いて、一見ふつうの1枚の和紙に見えますね。

　でも実はこれが二層紙で、剥ぐことができるんです。剥がない状態と剥いだものでふたつの厚さになることで色の濃淡が生まれるため、色を重ねることで作品を表現するちぎり絵に人気の紙です。断層のようにいろんな厚みができることもあり、それもまたいい表情になります。「紙の温度」のスタッフで、剥ぐおもしろさにはまった者もいました。広瀬町には長らく長島さんの工房が1軒のこるのみだったのですが、彼の工房で修行した大東由季さんが今年独立し、2軒となりました。大東さんは27歳、広瀬和紙の若き後継者の誕生に、長島さんも喜んでいることでしょう。

166

写真左上から肌裏、美須、宇田。

福岡・八女

肌裏、美須、宇田 ── 八女手漉き和紙

表具に使う和紙の先達に敬意を払って
一文字変えた名にしています

日本茶の産地として知られる福岡県八女市には、和紙工房もいくつかあって、みなさん表具用の紙をつくっています。八女周辺の楮は繊維が長く、丈夫で耐久性に富んだ紙ができます。表具用の紙というと、139ページで奈良県吉野の宇陀紙を紹介しました。修復や表具の歴史としては吉野の方が古く、八女は後発です。そのため八女の方たちは吉野に敬意を払い、同じ呼称でも漢字を変えるなどしています。作品への最初の裏打ち「肌裏打ち」に用いられる美濃和紙の「薄美濃」に対して、八女では役割のまま「肌裏紙」と言います。厚みを調節する役割の「増裏」に用いられる吉野の胡粉入りの「美栖紙」に対して、八女は石粉入りの「美須紙」。そして最後の裏打ち「総裏」に用いられる吉野の「宇陀紙」は、八女では「宇田紙」と書いて区別しています。どれも吉野より求めやすい値段なので、気軽に修復したいという時に出番が多い紙です。

# 織紙、紙布

人にも環境にもやさしい紙づくりとは
産地で生まれ育っていないからこその自由さ

「水俣浮浪雲工房」の金刺潤平さんは、熊本県水俣を拠点に紙を漉いています。　静岡県出身の金刺さんが水俣に居を構えたのは、公害病である水俣病がきっかけでした。大学卒業後、日本青年奉仕協会のボランティアで水俣を訪れて1年間活動した後、この土地に工房を開きます。作家として水俣病と

に向き合ってきた石牟礼道子さんから、水俣病の患者とできる仕事として和紙づくりをすすめられたことがきっかけで、

「人にも環境にもやさしく」という信念のもと、指先の感覚や嗅覚にも障害を持つ彼らを思い、薬品に頼らず漉くことを心がけたのも、金刺さんならではです。「捨てられゆくものを生かす」をモットーに、これまでにタマネギの皮、規格外

のイ草、バナナの木、履き古したジーンズなども原料にしてきました。イグサの無蒸解パルプの開発は、第二回ものづくり日本大賞優秀賞を受賞しています。　和紙の産地で生まれ育っておらず、水俣という、現在はほかに紙漉きのいない土地

での活動は、苦労も多いだろうと察します。ですが、親譲りではないからこそ生まれる自由な発想があり、力強さを感じるひとりが、この金刺さんです。

現在は、楮を編んだ「織紙」があります。楮の繊維を叩いて、漉かずに編んで重ね合わせています。色つきのものは光

沢もあって、敷物にしたりと用途を考えるのが楽しい1枚です。小さな紙布もつくっていて、こちらは奥さんの宏子さんが担当しています。金刺さんが漉いた和紙を撚って糸状にして、紙布をつくります。緯糸は紙で、経糸は木綿という組合せのものもあって、機織作家である宏子さんの腕がいきています。

和紙のこより糸を使ってつくられた紙布。

熊本・水俣

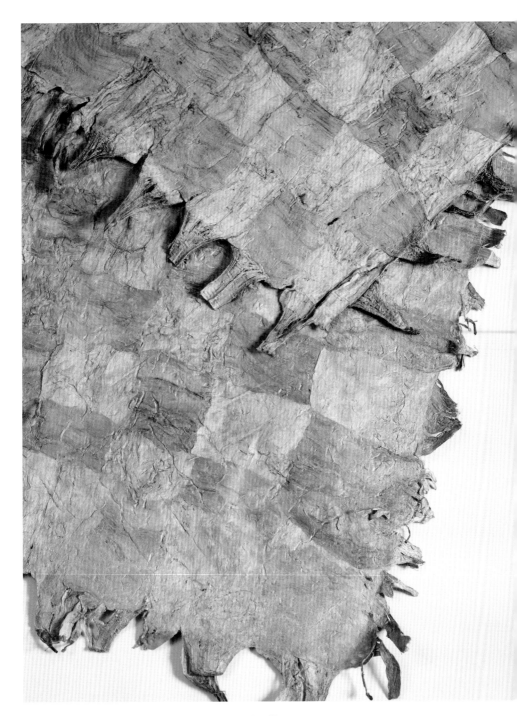

楮を叩いて織り、さらに叩いて光沢が出た織紙。

# 梶の木和紙 ── 名尾和紙

カジノキでつくった丈夫な和紙
薄くて光を通すから提灯に向きます

耳（紙の端）の部分に長い繊維が見える、カジノキからつくられた和紙。

佐賀・名尾

佐賀県名尾では、谷口祐次郎さんの工房「名尾手すき和紙」が1軒でがんばっています。名尾は原料に楮の仲間であるカジノキを使います。タイで使われている、あのカジノキです（20ページ参照）。楮と比べて油分が多く繊維が長いため、丈夫な紙ができます。カジノキは漢字では殻の木または梶の木と表記します。この木のことを知らない人も多いので、お店では「丈夫な楮紙ですよ」と伝えした方が、理解してもらいやすいですね。谷口さんはカジノキの栽培から行っています。

元々は障子紙として多用されていたのだと思いますが、丈夫さと光を通す薄さを兼ね備えていることから、提灯に使われることも多いです。子どもが揚げるくらいのサイズの凧用の紙としても人気です。また、長崎諏訪神社のくんちに奉納される「長崎龍踊り」の龍にも、この紙が使われています。

芭蕉の繊維が見える芭蕉紙。

## 芭蕉紙 ― 琉球紙

バナナの仲間の多年草からつくられる紙
原料は芭蕉布と同じ糸芭蕉です

首里城の近くにある「手漉き琉球紙工房 蕉紙菴」の安慶名（あげな）清さんは、芭蕉紙を漉いています。芭蕉紙は1717年に誕生したという記録があります。明治時代に一度途絶えた芭蕉紙を復活させた立役者は、出雲の安部榮四郎さん（162ページ）と、弟子の勝公彦さんです。1978年のことでした。安慶名さんは会社員生活の後に勝さんに弟子入りし、技術を会得しました。原料となる芭蕉は、バナナの仲間の多年草。観賞用の花芭蕉と実を食べる実芭蕉、そして繊維から布と紙をつくる糸芭蕉があります。茎を切ると年輪のように見えますが、数十枚の皮を取り巻くように重なり合っています。一枚一枚皮を剥がし、芭蕉布の糸になる繊維を取り除いた捨てられる皮（バサケー）が、紙の原料です。芭蕉の繊維は強靱で、非繊維素が多量に含まれています。安慶名さんの芭蕉紙は繊維も見えて、素朴です。海外のバナナペーパーと比べると繊細で、同じような原料でも国によって印象が変わるのは、ロクタと同じですね。

写真左が薄手、右が厚手の月桃紙。

　月桃紙も芭蕉紙と同じく、沖縄独特の紙で
す。月桃はショウガ科の常緑性多年草。古来
漢方薬として利用されてきました。健胃、整
腸、食欲増進、咳止めなどの効能があるそう
です。そして沖縄で、サトウキビ畑の周囲に
植わっているのを見たことがあるという人も
いるでしょう。あれは月桃の葉が防虫効果に
すぐれているからなんです。それをなにかに
活用できないかと宍倉さん（76ページ）が在
籍していた会社が相談を受け、めでたく紙に
なったという背景があります。月桃の繊維は
けっこう長くて、漉いた紙にも繊維がのこっ
ています。「日本月桃」がつくる手漉き月桃
紙は厚手と薄手の2種類があります。壁紙と
しても人気で、その場合は月桃紙壁紙を使い
ます。「紙の温度」では手漉きの月桃紙のみ
を扱っているので、厚手の手漉き月桃紙を壁
紙として使っています。

172

# こんなに素敵なお店は
# お店はどのように生まれたか

ここまでご覧いただいて、「紙の温度」にある紙がどれだけバラエティーに富んだものか、おわかりいただけたと思う。「紙」とひとくくりにしていいのかと思うほど、さまざまな表情があり、その用途もいろいろだ。これらの紙を1枚1枚見て選んできたのが花岡さんであり、店長の城ゆう子さんはじめ店頭に立つ社員である。「出会ってない紙が山ほどある」と花岡さんは言うけれど、品揃えは一番という自負もある。

「国内はもちろん、世界中のいろんなお店に行きました。イギリス、フランス、アメリカなど、評判を聞いて回ってみましたけど、びっくりしませんでした。狭く深くというお店はありますけど、うちのように総合的に展開しているところは他にないのかもしれません」

### 始まりは家庭用の紙

「紙の温度」がオープンしたのが1993年、花岡さんが50歳のときだった。では、それ

まで花岡さんはなにをしていたのだろう？　開店までの背景と花岡さんのキャラクターを知ると、「紙の温度」という唯一無二の個性を持つお店がなぜ生まれたのかがよくわかるので、少し時間をさかのぼっていきたい。

花岡さんの生家は慶応2年（1866年）から続く紙問屋であり、古くは和紙を扱い、その後は家庭紙を中心に名古屋圏で商売をしていた。一人っ子ゆえ幼いころから家業を継ぐことに疑問を抱くことなく、進学校に進んだものの大学へは行かず、高校卒業と同時に社会人になったという。1960年代初頭のこと、日本は高度経済成長に沸き、生活を取り巻くさまざまな環境が大きく変わっていく時代である。鼻紙がティッシュペーパーに、ちり紙がトイレットペーパーになり、家庭紙の世界もめまぐるしく変わった。そしてこの時期に、スーパーマーケットが全国で続々とオープン。家庭紙の売り場は化粧品店や薬局といった小売店から量販店へとシフトしていった。

「商売は順調で、売上も年々伸びましたが、競争が激しくなるにつれて利幅は小さくなっていく。さらに家庭紙はトイレタリーという業界に組み込まれ、それまでとは異なる商習慣に戸惑いもおぼえました」と花岡さんは当時を振り返る。たとえば量販店の棚卸しの応援要員として社員を派遣したり、年末も駆り出されたり。メーカーと量販店が直接商売することも増え、問屋の存在価値も揺らいでいく。紙屋なのだから紙屋の考えで生きたいという気概と、トイレタリー業界の商習慣に慣れりもおぼえるなか、家庭紙という商いに生きがいを感じられなくなっていった。1980年代半ばの頃である。

そんなモヤモヤした気持ちを抱えていたとき、花岡さんは新たな出会いを得る。麻田孝治さんという、アメリカで生まれたコンピュータの棚割ソフトを紹介し、カテゴリーマネジメントという概念を最初に日本に持ちこんだ先生だ。大阪で開かれた麻田さんの勉強会に社員

花岡さんの生家である
紙問屋（大正時代の頃）。

と赴いたのをきっかけに、花岡さんの会社で経営理念などを説いてもらうことになった。

## 斜陽の和紙はダメじゃない

　ある時、名古屋駅まで送る車中でのこと。麻田さんは花岡さんに言った。「小さな会社を、隙間を狙ってつくりなさい。そのときに、決して紙から離れてはいけない。ほかの業種に手を出したら失敗するのは目に見えている、絶対に紙でがんばれ」

　この言葉を受け、花岡さんは本業をしながら社員と一緒に市場調査を行った。当時ラッピングブームが起きていて、そこに可能性があるのではと東京に行ってヒアリングしたところ、日本のようにお店がきちんと包装してくれる習慣を持つ国では根付かないと、どのショップオーナーも口を揃えた。実際、一過性のもので根付かず、どこも廃業したという。

　そうやってリサーチを続けていたら、麻田さんに一喝された。

　「やったことのないものをどれだけ勉強しても答えは出ない。迷うよりも50歳までにとにかく始めること。順調にいけば15年後20年後にはなんとか形になっているだろう。それが55歳60歳と後ろ倒しになってしまってはものにならないよ。50歳を過ぎたらやってはいけない」

　そのとき花岡さんは48歳。待ったなしだ。さらに「趣味道楽でやるのではないから、まずやるものの骨格を書き出すこと」と助言をもらい、書き出したのが次の10箇条だ。

　　価格決定権を持つ
　　主体性を持つ

限りなく消費者に近づく

小さな組織

基軸から外れない

大企業が参入しにくい分野、仕組み

人を大切にする

マーケティング力を生かす

行動の重視

困難な仕事を厭わない

「量販店にされてきたことの裏返しです。主体性が持てなかった、価格決定権を奪われた、消費者に近づけなかった……。だから全部反対のことを書きました。この10箇条を客観的に見たときに、『斜陽の和紙はダメだ』とは書いていないことに気づきました。それが変ないわけになったというか。創業時は和紙を扱っていましたし、マーケティング力も多少はある。このことをきっかけに、和紙の産地を訪ね始めました」

## 和紙ってあったかい

　もちろん、和紙が斜陽産業だということは、骨の髄までしみていた。花岡さんが入社した当時、すでに斜陽だったくらいだからだ。和紙の生産者を訪ねるにも、当てがあったわけではない。無謀とも思えるこの行動力の裏に、「屁理屈はあったんですよ」と花岡さんが教えてくれたのは、お店のすぐそばの熱田神宮のことである。

「熱田神宮には、商売にご利益のある上知我麻神社があるんです。だから御守りいただけるだろうと。その上、『神』と『紙』、父の説得はこれで大丈夫と踏みました」

ちなみに「紙の温度」の店舗は元は、生家の紙問屋が所有するトイレットペーパーの備蓄倉庫だったもの。すぐそばを幹線道路が走り、人の往来のないロケーションで、周囲の人は「店を開く場所じゃない」と反対した。けれども名古屋の中心地に出店しようと思ったらとんでもなく費用がかさむ。

「ここしか空いてないんだからと開き直りにも近い気持ちでした」

手漉き和紙の名簿を入手し、それを元に日本中を歩いた。「ここには和紙を買いに来たと思わず、芋を買いに来たと思うこと」。東北のある産地でそう言われ、意味がわからぬまま生産者を訪ねると、お茶請けの漬物を食べながら一向に和紙の話にならない。「あの、今日は紙を買いに来たんですけど」、そう切り出すと、「納屋にあるから取ってらっしゃい」。和紙を取ってくるのも、納品書を切るのも花岡さん。

「ああそういうことか。ここでは和紙は農産物と同じ扱いなんだとわかりました」

そうやって日本中を巡るうち、大きく舵取りを変える和紙との出会いがあった。京都の黒谷を訪れたときのことである。花鳥風月や吉祥の文様を色鮮やかに染め上げた和紙の数々に、花岡さんと同行した社員は心を奪われた。それは沖縄の伝統的な染織技法「紅型染め」を用いたもので、伝統的でありながらモダンな雰囲気も持っている。みなさんはすでに132ページでご覧になった、あの美しい紙たちだ。それらを金山ちづ子さんがひとりでつくっていると知るのは後になってからのことだが、いまでも「紙の温度」では豊富に揃えている。

「和紙を扱う家に生まれましたが、私の代で実は和紙を一度切りました。「紙の温度」では豊富に揃えている。家庭紙と手漉き和紙はまるで違う世界ですから、知識はそこまでありませんでした。そして日本の産地をま

「紙の温度」開店当時の店舗風景。
最初は現在の北館のみだった。

わりながら、本当に店を開くか、どこかでまだ迷いがあったと思います。でも黒谷で紅型染めの和紙を見て、こんなに素敵なものがのこっていることに驚き、斜陽でもいいじゃないかと心を決めたんです。それくらい感激しました。こういう紙を集めれば面白い店になる、斜陽なんかじゃないと自らを暗示にかけていったんです」

実はこの日はもうひとつ、大きなことが決まっていた。それは花岡さんもあとからわかったことだった。黒谷で紅型染めを見て興奮冷めやらぬ帰りの道中、「いよいよやるか」と社員とも決意を共にする中、さまざまに話したことをレポートするように伝えた。するとそこに「紙の温度」という言葉があったという。

「和紙はあったかいねとか、そういう話をしたことを、社員なりの言葉で書いたのでしょう。それから1年くらいして開店の準備も本格化し、さあ店名はどうするかとなって、いろんな言葉を100以上は出したんじゃないでしょうか。ああでもない、こうでもないと頭をひねるうちに、あのときの『紙の温度』が頭をもたげたんです」

開店に関わってもらったデザイナーからは反対された。「の」を店名に入れてヒットすることは稀だし、「紙屋院」のような歴史を感じる名前の方がいいだろうとも言われた。でも「紙はあたたかい、紙のぬくもりを感じてほしい」と考える花岡さんは、「紙の温度」で押し通す。そうして1993年3月22日、お店はいよいよオープンした。

## 半年したらつぶれるよ

オープン当初、扱った紙は1200種類ほど。すべて手漉きの和紙で、機械抄きも海外の紙も一切なかった。紙漉きを体験できる工房もあり、「紙の温度」ならぬ「和紙の温度」を

「紙の温度」オープン時に出した
ダイレクトメール

呈していた。

「置いているのは値段の高い和紙ばかり。お客さまからしたら買いにくい店ですよね」と花岡さんも当時を振り返る。そして開店初日、花岡さんにとって強く記憶にのこる人物との出会いがあった。

「ここの経営者を呼びなさい」

駆けつけると開口一番、

「こんな店、半年で潰れますよ」

店を開けたその日に聞きたい言葉ではない。でも花岡さんはそうは考えなかった。

「よく言ってくれました、いろいろ教えてください」と頼んだのである。

嶋田紀子さんというその女性は、折紙講師で和紙のことをよく知る人だった。品揃えをどうすべきか、まだ店にない古い柄の和紙のことなど、たくさんの助言をくれたという。もうひとり、開店してすぐに貴重なアドバイスをくれたのが海部桃代さんだ。『和紙の花 日本の四季』などの著書もある方で、東京で和紙のお店を開いていたこともある。そのお店がうまくいかず閉めた経験から、「いい和紙を見て惚れちゃうと、そういう和紙ばかり揃えてしまう。でもそれではだめで、お金を稼いでくれる紙も置くようにしなさい」と、非常に具体的に教えてくれたという。

話を聞いていると、花岡さんは要所要所で恩師と呼べるような人に出会っている。麻田さんしかり、嶋田さんも海部さんも、よくぞそのタイミングで花岡さんの前に現れてくれたと感じてしまうほどだ。そしてそういう出会いが、現在に至るまで何人も、脈々と続いている。もしかしたら花岡さんは、そういう人たちに出会った時に直感で察する能力を持ち合わせているのかも知れない。

「紙の温度」開店当時のスタッフ。
左から2人目が城さん。

## 置いている紙のすべてがロングテール

どんどん売れるものでもないし、名古屋駅からも距離がある国道沿いという立地はふらっと来られるロケーションでもない。すぐに売上が伸びると思っていたわけではないけれど、開店したての頃は売上ゼロという日もあったという。でも花岡さんは、家庭紙の問屋だったときの「回転率が勝負」という世界に辟易していた。薄利多売の極みのその世界がいやだったから、回転は悪くてもいい、ゆっくり穏やかな商いをしようという覚悟のもと、社員とともに耐えた。

そうするうちに、一度訪れたひとが二度三度と足を運んでくれるようになり、お店の会員になってくれた人たちにダイレクトメールを送ると、その反響も感じられるようになってきた。2年目からは、折紙、王朝継ぎ紙、ちぎり絵など、さまざまな教室もスタート。王朝継ぎ紙はちょうどテレビで紹介されているのを見た長野隆さん（186ページ参照）から『紙の温度』にぴったりだ！」と知らせをもらい、出演していた近藤富枝さんのお宅にすぐに向かった。一生懸命取り組むなら応援しますと請け負ってくれ、教室を開くことを快諾してくれたという。

この取り組みは、「紙の温度」にとってだけでなく、受講する人たちにとっても大きなメリットがあった。たとえば王朝継ぎ紙で、仮名文字を書くための料紙づくりには、何枚もの和紙が必要となる。しかも季節によって異なる色や絵を用いるのだが、それぞれ必要な和紙は1枚ずつ。問屋は100枚という単位で売りたいから、思うように材料が買えず愛好者の人口はなかなか増えなかった。それが「紙の温度」の教室に参加すれば、お店の紙を1枚ずつ買えて、好みの料紙を仕立てることができる。結果、評判を聞きつけた仮名書道の大家の

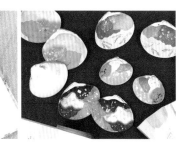

王朝継ぎ紙の教室で
生徒さんがつくった作品。

方々が大勢訪れてくれるに至った。最初は和紙関連の教室が占めていたが、後述するカルトナージュやリュール、クイリングなど洋風の教室も増えていった。お客さまとして来店していた人が、「私もここで講座を開きたい」と名乗りを上げてくれることもあったという。

欲しい紙が1枚から買える。お客さまにとっては大きなメリットだが、お店はその1枚のために在庫しておく必要がある。

「手漉きなら一釜分（300〜400枚くらい）、既製品だと50枚というのがロットの単位であることが多いんです。1枚のために買うか買わないかの決断をしないといけない。本当に年に数枚しか売れない紙もあります。でも二度とつくれない紙もありますから、あるときに仕入れておかないとなくなってしまう。それにその場で買わずに、しばらくたってからお求めになる方も多いんです。『この間見た紙をください』って言われて、この間っていつ頃でしょうとうかがうと5年前だったりして（笑）。必需品じゃないから、リードタイムがすごく長いんですね」

でも「はじめに」で述べたように、お店の合い言葉は「きっとある」。「お客さまに教えてもらう」姿勢を貫き、リクエストされたら何でも置くのがお店の方針。希望の紙そのものが探せたら一番いいし、それが無理ならできるだけ近いもの。珍しい紙を購入しようとしている人には用途をたずね、新たな分野の開拓にも熱心に取り組んだ。そうやって探し続け、在庫し続けた結果が2万アイテムという品揃えになっている。もし100枚いっぺんに売れる紙をヒット商品と呼ぶならば、「紙の温度」にヒット商品は置いていない。すべての紙がロングテールだと花岡さんは言う。みんなちょっとずつ売れる、隙間アイテム。大切に保管され、出番を待ち続けている。本当に家庭紙の真反対だ。

「きっとある」の合い言葉が入った、
「紙の温度」の年賀状。

## アジアへ、ヨーロッパへ、アメリカへ

いま「紙の温度」には、世界中から集められた紙が置いてある。でも先述したように、開店当初は手漉き和紙だけを置いていた。海外の紙を扱うようになったのは、買いやすい紙も置くようにと言う海部さんのアドバイスが大きかった。

「手漉き和紙はもちろんいいんですけど、良すぎるという面もある。そして値段も高い。もっとお値打ちの紙を探そうということで、まずはアジアに目を向けました」

最初に向かったのは、タイ。1995年のことである。タイにはタイ楮とも言われるカジノキがあり、日本の楮に比べると油分が多く、丈夫な紙になるという。日本の産地を巡ったときと同様、どこに行くべきか当てがあったわけではない。しかもインターネットがまだそこまで普及していない時代のこと。大使館に問い合わせて、見本市へと赴いた。その後ネパール、ブータン、ミャンマー、フィリピン、韓国と取引する国は増加。「和紙の代替品」としてだけでなく、和紙にはない素朴さや大らかさを気に入る人も多くいて、各国の特徴あふれる紙を豊富に揃えている。花岡さんは社員と共に生産の現場にも足を運び、紙に対する考え方の違いも実感した。

「和紙だって手漉きのものは1枚1枚表情は異なります。厳密に言えば、同じ楮でも去年のものと今年のものでは異なる紙になる。でもアジアの手漉き紙はその比ではないんですよ。現地で見たものと届いたものがまるで違うなんていうのはよくあることです。虫が入ったまま漉き込まれていたり、髪の毛がまるで入っていたこともあります。文化が違うから、それがなぜダメなのかを理解してもらうのが大変です。我々日本人の繊細さは、彼らにとってはいい迷惑でしょうね」

ドイツ・フランクフルトで開かれた
紙と紙雑貨の見本市「ペーパーワールド」。
3人で商談している内の右側が花岡さん。

ヨーロッパの紙を揃えるようになったのは1997年から。ドイツのフランクフルトで開催される「ペーパーワールド」は、紙と紙雑貨に特化した見本市で、欧州はもちろん、世界中の紙が集まる。花岡さんは積極的に足を運び、まだ見ぬ魅力的な紙との出会いを求めている。ちなみにフランクフルト以外の見本市にもいくつも行っているけれど、アジアでもヨーロッパでも会場には紙以外のものが圧倒的に多く、同行の社員ともども「見つけないと店には帰れないぞ」と追い詰められたような気持ちになることもしばしばだとか。フランクフルトでは本国ドイツのみならず、イタリア、ベルギー、オランダ、イスラエルなど多くの国の紙を見るし、「紙の温度」に迎え入れている。手漉きだけでなく機械抄きもあるし、マーブルペーパーやプリントペーパーなど、二次加工を施した紙の豊富さは洋紙ならではだ。見本市に行ってメーカーと直接やりとりするため、日本の代理店が持っていないものも「紙の温度」にはある、ということもよくある。

そしてアメリカの紙も、もちろん扱っている。中でも紙の温度で豊富に揃えているのが、64ページで紹介した「スカイバーテックス（「紙の温度」では「スカイバーテックスと表記」）」の擬革紙だ。文字通り革に似せたエンボス加工を施した紙で、花岡さんはお客さまから「カルトナージュに使うスカイバルテックスは置いてないの？」と聞かれ、その存在を知った。カルトナージュは厚紙でつくった箱に紙や布を貼って仕上げるフランスの伝統工芸。

「フランスの伝統工芸なのだから、紙も当然フランス製だと思って探し回ったわけです。でも見つからない。それもそのはず、アメリカの会社の紙だったんですから」

見つけてわかったのは、スカイバーテックスはカルトナージュ専用ではなく、高級なチョコレートやワインの箱などに広く使われる紙だった。「紙の温度」では色も柄もとにかくたくさん揃っていて、スカイバーテックス本社の人が来店したときに驚かれたほど。世界中で、

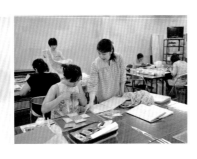

右）「紙の温度」北館2階で開かれたカルトナージュ教室。
左）カルトナージュ教室の生徒さんがつくった作品。

ここまでシートで揃えているのは「紙の温度」だけでしょうと花岡さんも自負している。

## 替えの利かない人たちが漉いている

それにしても「紙の温度」に置いてある紙に囲まれると、世界中でこんなに素敵な紙をつくっていることに感嘆する。輸入品では漉き手や生産者にまだ会えていない紙もあるが、和紙に関しては東北から沖縄まで、ほとんど花岡さんや「紙の温度」の社員が直接会ってやりとりしている。だから楮、三椏、雁皮といった原料ごとの紙の特徴を把握しているのはもちろんのこと、産地の特徴や得意分野も比較できるし、なによりつくり手によって異なる紙の個性を熟知していて、それを話す時の花岡さんはとても嬉しそうだ。

紙に惚れると同時に、人にも惚れ込む。一産地の一生産者というより、「替えの利かない人」に出会った時はなおさらだ。そういう人が漉く紙はこだわりがありすぎて、どんどん売れるものではないこともある。商売的には成功と言えなくても、花岡さんはじっと待つ。

「ちょっと早すぎるんですね。たくさん失敗してきました」

それでも可能性を信じ交流を続けることで、互いの信頼は篤くなる。いまでも花岡さんが直々に担当している人も多くいるし、「紙の温度」にだけ紙を出すという人もいる。彼らにとっては、花岡さんこそ「替えの利かない人」なのだろう。

## 常識から外れてでも、紙に触れてもらいたい

「紙の温度」という店名が示すように、手漉きの紙はあたたかい。空気をはらんでいると

言えばいいだろうか。そこが手漉きの紙の大きな魅力であり、写真やモニター越しに見ていてはどうにも伝わりにくい部分である。それは開店前から花岡さんもわかっていたことで、だからお店に来てくれたからにはぜひとも直に触れて欲しいと願った。しかしこれが社員みんなと大きな議論となった。当時シート状の紙を扱う店舗では、紙に触らせないところが多かったからである。日本だけではない、海外の店舗でも同様で、花岡さんは触って怒られたことが何度もあるという。

「触れると汚れたり破れたりして、それらは当然ロスになります。でも触れてもらわないと、和紙の良さはわからないじゃないですか。ここが洋紙とは大きく異なる点ですね。たとえロスが出てもいいからとにかく触ってもらおうと。どんな紙も、すべて触れることができるようにしました」

また、手漉き和紙は農産物と言われたように、工業製品でない手漉きの紙は「規格品」という範疇になく、当然ながらJANコードが付いて流通されていない。「紙の温度」では花岡さんが量販の世界を経験してきたことを活かし、社内でバーコードを起こして商品管理している。「そういうこと、職人さんたちはやりませんから」と言うものの、同じ職人さんが漉く紙でも、厚みや色やサイズごとにすべて品番を起こして管理するのは大変な労力であることは想像に難くない。でもそれをすることで、オンラインショップでも品番で検索可能になり、リピートにも応えられる体制が整っている。

そしてすべての紙に値段のシールを貼っている。紙の裏側に貼っているのだが、それでも「はがすときに破れちゃったらどうするのか」という声が多く寄せられた。そこでそういう心配のある紙は1枚ずつ透明の袋に入れて、袋にシールを貼っている。これもスタッフがひとつひとつ行っている。

全ての紙にバーコードが
貼られている。

185

「難しい商売だと痛感しています。でも困難はいとわないと決めましたから」という花岡さんの心意気が、紙だけでなくお店そのものをあたたかな空間にしている。

## たくさんの人がお店を育ててくれた

先述の通り、花岡さんは要所要所で恩師と言うべき人に出会っている。すべての方々を紹介しきれないほどだ。商品開発やプロデュースの分野で活動していた長野隆さんは、「紙の温度」開店に際して「Pプロ企画」と題した店の骨子となる文書をつくってくれた。A4サイズの紙4枚にまとめられていて、なにを大切にして、どんな店を目指し、どんなことを武器とすべきかといったことがとても簡潔かつ的確に記されている。中でもハッとさせられるのが、文書の最後の項目「敗退する理由」だ。「人が支えてくれなくなったとき」「情熱が消えたとき　自信がなくなったとき」「情熱が片寄ったとき」にわけて説いていて、最後の「情熱が片寄ったとき」はさらに具体的にこう記されている。

作ることのみに、集めることのみに片寄ったとき
利益や売上に追われてバランスが崩れたとき
合理的な事のみに、採算のみに意識が働いたとき
知識や知恵のみに片寄ったとき
広い情報・深い情報を持てなくなったとき
信頼する者が片寄ったとき

どんな商売にも、どんな仕事にも通じる普遍的で大切なことであり、そのことを直に伝えてくれる人が、新たな挑戦に挑む花岡さんのそばにいた。何度でも読み返したくなる、「紙の温度」にとって原点のようなものだろう。

コンサルタントの古井君多郎さんは、開店当初にふらりと立ち寄ってくれた。その昔、愛知県が主催した「新世代産業指導セミナー」に花岡さんが参加した際に講師を務めていて、その骨っぽい考え方に魅了され、会社の合宿にも来てもらった。

「海軍出身で、人の生き死にを目の当たりにしてきた方ですから、とても厳しい。でも非常に論理的な思考をなさる。ビジネスは矛盾をはらんでいるということを教え込んでくれました。正解のない問題をどんどん出されたりしましたね」

ちなみに古井さんは、開店した日にやってきた折紙講師・嶋田さんのご主人の上役だったとか。不思議な縁が、花岡さんのまわりに広がっている。

また、量販店が社員教育に熱心だったのを見てきたこともあり、花岡さんは社員教育にも力を入れてきた。たとえば紙の専門家による勉強会を定期的に開催して座学で知識を深めている。76ページで紹介した宍倉佐敏さんが2005年から講師を務めていて、樹種によって異なる和紙の特徴についてはもちろんのこと、紙の出来を握る「繊維」について非常に詳しく教えてくれる。社員でなくても受講したいくらいだ。それ以外にも、心理学の先生を招いていたこともあるというからユニークだ。塹江清志さんという人物で、「自己客観視」することの大切さを説いてくれた。ものごとを考える時は常に対比して、反対側からも考察するのだと。お客さまを相手にする仕事において不可欠な視点である。

紙の繊維分析について
講演する宍倉さん。

# 2001年、ロンドンに和紙がやって来た！

和紙人形の第一人者と言われる中西京子さんと夫でプロデューサーの中西弘光さんとは、銀座で開催された京子さんの展覧会を訪れたことから付き合いが始まり、「紙の温度」でも教室を持ってくれた。あるとき「ロンドンで人形の展示をしたいから、三六判（90×180センチ）サイズの紙を貸してくれませんか」と言われ、展示の背景に使うのだろうと考え請けおうことに。すると事態は想像以上のスケールへと展開し、なんとシェークスピア劇の上演で有名なグローブ座の地下スペースで「Wrap the Globe in Washi」と題した、人形だけでなく和紙そのものを見せる展覧会になってしまった。

シェークスピアと江戸時代の日本の芝居小屋をテーマに、ものすごい数の和紙人形が展示されることに。人形のサイズは50センチから80センチとかなり大きく、和紙人形の表情がはっきり見て取れる迫力あるものである。ジオラマのスケールも精巧さも高いレベルのものがつくられた。その舞台の緞帳を手漉き和紙のタペストリーに変えることになり、花岡さんはタペストリーづくりを依頼された。三六判サイズの和紙のタペストリーを11枚と12×4メートルの巨大タペストリー（下写真右）を製作。この展覧会は好評を博し、日本でも各地を巡る。

越前の長田製作所に漉いてもらい、3×5メートルのタペストリーを11枚と12×4メートルの巨大タペストリー（下写真右）を製作。この展覧会は好評を博し、日本でも各地を巡回、「紙の温度」の本拠地とも言える名古屋でも開催された。

現在、展示したタペストリーのうち3枚が店内に飾られている。お店に行ったら、ぜひ見てほしい。

ロンドンで行われた
「Wrap the Globe in Washi」
に飾られた、「紙の温度」
制作の幅12m、高さ4mの
巨大な和紙タペストリー。

188

## つくる人と一緒に、紙の世界を豊かなものに

花岡さんが開店以来決めていることのひとつが「手漉きの和紙は値切らない」こと。

「量販店の無理な要求によって採算が合わずに廃業するのを、家庭紙や同業の卸売でたくさん目にしました。それが辛くて、自分は値切らないと決めたんです」

手漉きの紙は豊かな自然に囲まれた地域でつくられているが、その自然が大きな敵となることもある。増えすぎた鹿に原料の芽を食べられてしまって、その年は紙が漉けなかった人もいる。そもそも職人さんたちの儲けがとても少ないことも知っているから、なおさら値切ることはしたくないのだと言う。「きれいな紙が漉けたけれど全然売れない」と言われればあるだけ買い、「仕事がない」と泣きつかれたら新たな紙を一緒に考えて漉いた分はやっぱり全部買う。

商売だけれども、いい和紙を絶やしたくないという強い思いがそこにはある。

書道、修復、装飾といった役割を持って生まれた和紙以外に、なにに使うのかはっきりとした目的を持たないものもある。

「それが洋紙と和紙の大きな違いですね。洋紙はすべて目的があって生まれています。目的が明確でない紙はなかなか売りにくいのですが、でもうちにあることで新たな用途が見つかるのではないかという期待を抱いて置いています」。これも花岡さんの心意気である。

そして多くの人に紙の楽しさ、美しさを知ってもらうために、花岡さんは社員と共に積極的に行動し、紙を取り巻く世界の可能性を拡げている。その一端が、オリジナルの紙づくりだ。たとえば、本拠地である名古屋は紙の産地ではない。ならば自分たちで企画しようと思い立ち、呉服の「名古屋友禅」と「有松絞り」を和紙に染めてもらうことに。この試みは1998年から続いている。また、漆職人と共同研究して本漆を塗った擬革紙をつくってい

「Wrap the Globe in Washi」の
タペストリーをつくったことで、
現地で表彰を受けた花岡さん。

る。漆は塗ったあとに硬化するので、紙を折ると表面も折れてしまう。それを技法を開発して、折り曲げられる紙に仕上げてある。革の代わりに用いるサステナブルな紙をつくりたいという思いと、美しさを持続させるための技術が、この紙には込められている。またちりめん揉み紙の技術は後継者が少なく、できるひとも少なくなっている。その技術を「紙の温度」の店長である城ゆう子さんが職人に弟子入りし時間をかけて習得。その技術がのちのち生き、伊勢擬革紙復活の手助けにもつながった。

## 手から生まれる紙を絶やさぬために

店をオープンしてもうすぐ30年。その間に紙を、とりわけ和紙を取り巻く環境はどう変わってきたのだろう。

「斜陽は進む一方だと感じています。私たちが生産地を巡るときに参考にした手漉き和紙の名簿には、400軒くらい載っていました。いまは100軒くらいになってしまったのではないでしょうか」

厳しい状況ではあるけれども、和紙づくりは日本が誇る伝統産業であることは変わらない。2014年には「和紙 日本の手漉和紙技術」がユネスコの無形文化遺産に登録された。これは喜ぶべきことではあるけれども、その時代に栄えているものではすでになくなっているから「遺産」なのであり、未来にどうのこしていくか┐という大きな課題がそこにはある。だからこそ「紙の温度」は在庫が増えることをいとわず、いま買わなければ二度と手に入らなくなってしまうかもしれない価値ある紙を、積極的に入手する。

「伝統的なものって、時間を短縮した途端にだめになってしまうんです。たとえばちりめ

「紙の温度」店長の城さんが
ちりめん揉み紙づくりを実演。
今では知る人も少なくなった
貴重な技術。

ん揉み和紙は、専用の型紙で和紙を縦横斜めに揉むことで、柔らかく扱いやすいように仕上がります。江戸時代から伝わる加工技術です。その型紙をつくる工程で柿渋を塗るんですけど、これは炎天下の暑いときでないといけない。塗りすぎるとシワが伸びちゃいますから、塗れたかどうかわからないくらい。しかもすぐに完成ではなくて、枯らすために2年3年と寝かさないといけません。それを繰り返す。ほかにも、手づくり味噌にかぶせる薄い紙を美濃の加納さんに頼んだのですが（120ページ参照）、通常は原料の楮を洗う時間は2時間くらい。でもこの味噌の紙は11時間洗わないといけない。そういうことを引き受けてくれるのが加納さんという人です。手間ですが、手を抜くとものにならない。伝統技術は根気です、紙でいいものをつくろうと思うと手間ひまだとつくづく思います」

また、紙漉きそのものをしている職人の名前は出ることはあっても、ちりめんや板締めといった二次加工したものとなると、そこに携わる人たちの名前が出ることは稀である。そういう側面もあってだろうか、二次加工の技術でなくなってしまいそうなものも多いという。

「ちりめんはかつて日本中にあった技術ですが、できる産地がどんどん減っています。板締めは染めはできるけど折る人のなり手が減っている。昔は内職のおばあちゃんたちがやってくれるものでしたが、そういう人がいなくなって値段も上がってきています。本当に、うちが扱わなければならなくなってしまう、その気持ちは強いです」

「紙の温度」に行ったら、和紙と世界の紙の魅力を存分に感じて欲しい。気に入った紙を手に取り、触れてみて欲しい。人の手から生まれたあたたかさが伝わってくるだろう。紙がもっと好きになるに違いない。魅力あふれる紙がこんなにたくさんあるなんて、なんて素敵なことだろう。なんて嬉しいことだろう。みんなで、紙の未来を明るいものにしていこう。

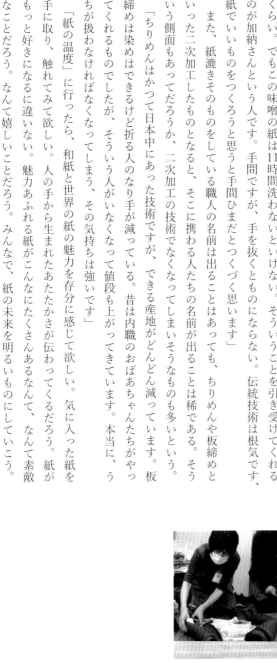

| 話 | 花岡成治（紙の温度株式会社） |
|---|---|
| | 城ゆう子（紙の温度株式会社） |
| 文 | 鈴木里子 |
| 紙の写真 | 井上佐由紀 |
| 協力 | 宍倉佐敏、紙の温度株式会社 |

| ブックデザイン | 中西要介（STUDIO PT.） |
|---|---|
| | 根津小春（STUDIO PT.）、寺脇裕子 |
| 校正 | 鷗来堂 |
| 企画・編集 | 津田淳子（グラフィック社） |

「紙の温度」が出会った
# 世界の紙と日本の和紙

2022年11月20日 初版第1刷発行

| 著者 | 紙の温度株式会社 |
|---|---|
| 発行者 | 西川正伸 |
| 発行所 | グラフィック社 |
| | 〒102-0073 東京都千代田区九段北1-14-17 |
| | tel. 03-3263-4318（代表） 03-3263-4579（編集） |
| | fax. 03-3263-5297 |
| | 郵便振替 00130-6-114345 |
| | http://www.graphicsha.co.jp/ |
| 印刷・製本 | 図書印刷株式会社 |

ISBN978-4-7661-3671-5 C3070
Printed in Japan